IMAGES
of America

BALLWIN

Government Center
14811 Manchester Road
Ballwin, MO 63011-4617

Bringing People Together

(636) 227-8580
Fax: (636) 207-2320
www.ballwin.mo.us

Dear Ballwin residents and friends of the city:

First, let me thank you for your interest in Ballwin, Missouri, a city that is steeped in history and rich in tradition. The bound volume you now hold in your hands chronicles our community's growth and development from 1979 to the present.

Ballwin was founded in the 1800's. Since then, the city has been blessed by the efforts of hard-working and forward-thinking citizens who helped build and expand its boundaries. Twenty-six years ago, the city published a book that traced the people and events that shaped the city up to that time. It told the story of early settlers who carved their homes from a rugged wilderness, of those who led the efforts to formally incorporate our city nearly 60 years ago, and of those of us who now call Ballwin "home."

Since the first printing, I am proud to say that Ballwin's size and population have doubled and its landscape is filled with lovely homes and burgeoning businesses. Today, Ballwin is a thriving and growing metropolis with a population that includes both long-time residents like me who can still remember when the town's main artery, Manchester Road, was still a road! It also includes new, young families who are paving the roads of tomorrow.

Picking up where the 1979 book left off, this second volume tells the story of a city very much in its adolescence – with its best and brightest years still ahead. For long-time residents like me, the book is like a "family album," a compilation of milestones and memories. Those who are new to Ballwin will consider it a reference and a promise of a bright and prosperous future.

I thank the members of the Ballwin Historical Commission for their leadership and dedication to preserving our rich history. I thank you as well for your interest in learning about Ballwin. I sincerely hope you enjoy this book and that it accurately captures all that Ballwin means to you.

Yours truly,

Walter S. Young
Mayor

IMAGES
of America

BALLWIN

David Fiedler

ARCADIA

Copyright © 2005 by David Fiedler
ISBN 0-7385-3446-3

Published by Arcadia Publishing
Charleston SC, Chicago IL, Portsmouth NH, San Francisco CA

Printed in Great Britain

Library of Congress Catalog Card Number: 2005925733

For all general information contact Arcadia Publishing at:
Telephone 843-853-2070
Fax 843-853-0044
E-mail sales@arcadiapublishing.com
For customer service and orders:
Toll-Free 1-888-313-2665

Visit us on the internet at http://www.arcadiapublishing.com

To my wife, Shelly, and our children, Aaron and Lauren.

CONTENTS

ACKNOWLEDGMENTS

The first history of Ballwin was published in 1979 by the City of Ballwin. It was researched and compiled by Dorthea M. Loehr and written by Caverly Scott Wallace. Because the first volume was so thorough, other than a relatively brief couple of chapters on early days of the area to help establish historical context, this present work is intended to focus on the people and events that have shaped the city since the first volume was released. Unless otherwise indicated, all photographs came either from the collections of the Ballwin Historical Commission or from the city itself.

For their help in so many ways and their unwavering commitment to preserving the history of this community, I would like to thank the members of the Ballwin Historical Commission. This book is their project and could never be possible without their generous supply of photographs, stories, documents, and memories. Esley Hamilton, historic preservation specialist for St. Louis County, completed an inventory of Ballwin's historic buildings in 1994, which provided some information used here. In its introduction, he noted how fortunate Ballwin is to have such an active and effective local historical society. I agree completely.

Additional gratitude goes to the staff of the City of Ballwin for their cheerful assistance in this work. In particular, I owe Haley Morrison, staff liaison for this project, a great deal of thanks.

Introduction

It's amazing how Ballwin has grown so, but still seems to maintain a feeling of a small town atmosphere. I think a lot of that feeling is because as the town grew, the people in charge always had, and do have now, a love of a town that they want only the best for. So many of the residents who moved to the town throughout the years have a special feeling for it, just as I and other "old time" residents have always had. That is why we chose to stay. We have the conveniences of a larger town or city, but a hometown atmosphere. This makes a good combination.

—Mille Wallace
Poetry at Random, Book Three, 1996

Ballwin, Missouri, today is a stable, developed community. It is centered around a commercial corridor along Manchester Road, and its mature subdivisions, schools, churches, and other community establishments seem to have been around forever.

It has not always been like this, of course. Back just 200 years when John Ball, founder and namesake of the city, acquired 400 acres along Grand Glaize Creek, the taillights and neon lights that crowd Manchester Road were but a distant dream. When he platted 23 acres that became the first city blocks of Ballwin some 170 years ago, he surely could not have imaged that generation upon generation would make their lives in homes built on those lots. Even formal incorporation came just 55 years ago, back when Ballwin was a little more than a wide spot in the road out in the country. The leaders of this community had a simple goal: to create a town that would offer modern services to its residents in its police, fire, and municipal services. It would be interesting to see their reactions to what Ballwin has become today, to see the house built on the foundations they laid.

The story of Ballwin's beginning, like so many other towns across the central and western United States, is that of restless pioneers constantly pushing west. Because of difficulties securing clear title to land or because of troubles with American Indians, these hardy men and women moved their families, frequently in the face of great risks, to find more and better land, more open space, more opportunity to succeed in agriculture or business, or more freedom to practice religion.

John Ball, the founder of Ballwin, was one of these pioneers. He was born on October 19, 1779, the son of James Ball, who had immigrated to the United States from Ireland prior to the Revolutionary War. When patriot fever broke out in the colonies, James Ball joined up with Washington's army in 1776 and, in 1781, moved to Kentucky, where the government granted him a tract of land because of his military service. Daniel Boone was already there, and

during a stay in Kentucky that lasted nearly 20 years, Boone and James Ball apparently became good friends.

In 1797, Boone and a group of settlers that included Ball and his family left their old Kentucky homes to pursue better opportunities farther west. The Kentuckians eventually settled in Missouri in areas near the Missouri River in St. Charles and Warren Counties.

John Ball was by this time an independent young man and most likely viewed this move as an opportunity to establish himself as an independent farmer and homesteader. He purchased 400 acres in February 1800 along Grand Glaize Creek and first moved onto his property in 1803, sowing two acres of corn and running livestock on other portions of the property. By the next year, he had a nursery and was on his way to fully establishing himself on his land. He married Mary Eoff in 1814, and this union produced two boys and nine girls.

In 1826, Jefferson City was declared to be the Missouri capital, an act that indirectly led to the founding of Ballwin. The state declared Manchester Road as the main route between there and St. Louis. A steady steam of improvements over the next 10 years transformed the road from a narrow trail to a road capable of handling horse-drawn wagons and buggies.

John Ball was no dummy. As he watched the ever increasing traffic going by his property, he knew he had been presented with a fine opportunity. Ball hired a surveyor named Josiah Davison to create a 17-block village spread out over 23 acres, each block subdivided into four smaller lots. Papers filed with the county recorder on February 7, 1837, label the new subdivision as "Ballshow" and describe it as being on the "Jefferson Road," 21 miles west of St. Louis and 2 miles west of Manchester. Ball must have changed his mind about the name, for just two days later, on February 9, he amended the statement to read, "The above town is named 'Ballwin,' being 23 acres of land bounded on the south by the road leading from St. Louis to Jefferson City, on the west by land owned by me; also on the north-east and south by land owned by me."

John Ball devoted one of the 68 lots in his new town for use as a cemetery. He was buried there in 1859 but did not lie undisturbed. Progress and expansion, including successive widenings of Manchester Road, eventually uprooted the little plot. Some of the grave sites were relocated to the Salem Methodist cemetery, where several of Ball's children are buried. Others, including John Ball himself, went to the Methodist cemetery in Manchester, where he and his wife, Mary, still rest today.

One

THE EARLIEST DAYS

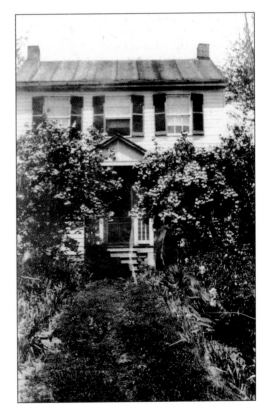

John Ball's home, no longer standing, is seen here on its Manchester Road site. Ball, who eventually founded the city that bears his name, purchased 400 acres along Grand Glaize Creek in 1800, when he was 21 years old. He began farming the property and running livestock. Seeing that Manchester Road, which ran past his property, was increasingly well traveled as the main route from St. Louis to Jefferson City, he laid out the first city blocks alongside the route in 1837.

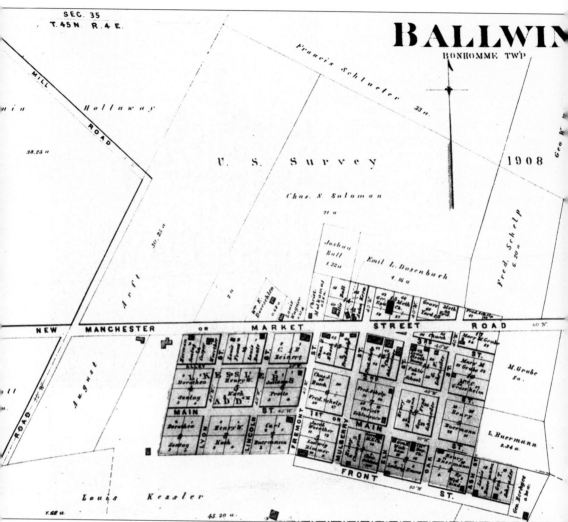

This is an 1878 survey of Bonhomme Township. John Ball's original town encompassed only 17 blocks of an acre each and sat at the highest point of the 340 acres he owned in survey section 1908. He originally called his town Ballshow in the papers filed with the county recorder in 1837 but amended the name to Ballwin just two days later. Of course one wonders about the name change, and a great-grandson of Ball offered over a century later that he opted for Ballwin as a result of rivalry with neighboring Manchester. John Ball saw great things ahead for his new town, said this particular descendant, and was certain that it would "win out" in reputation and growth over its older and more prominent neighbor, two miles to the east. There are no written records to support this conjecture, however.

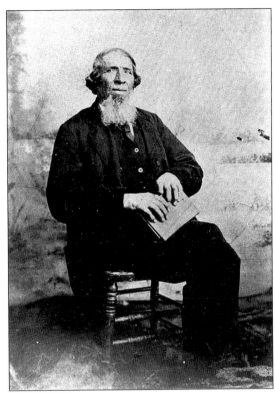

Following in the footsteps of John Ball, many German immigrants came to the area in the mid-1800s. These modest, hardworking people formed the backbone of the community as it slowly grew and prospered. From these folks many current residents can trace their own roots. They carried names like Bopp, Shelp, Buermann, Arft, Reinke, Woerther, and Zeiser. Among the earliest of these settlers was Dietrich Reinke (right), who emigrated from Germany in 1848. He settled in Bonhomme Township and began farming. Eventually Reinke ended up buying 140 acres, including part of what is now New Ballwin Park. The road that led to their farm was and still is called Reinke Road. He lived in Ballwin until his death at age 90 in 1910. His farmhouse is shown below as it appeared in the 1880s.

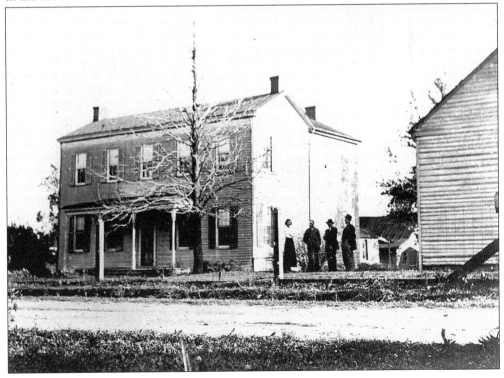

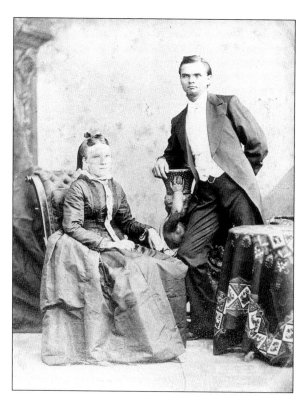

Life was not easy for people in the early days. Of John Ball's 11 offspring, 7 survived infancy and childhood, and he counted himself quite fortunate. Among Dietrich Reinke's nine children was Wilhelmina (left), who married Fred Erke in September 1875. Fred and Wilhelmina had six children. When scarlet fever raged through the area, five died over a 13-day period.

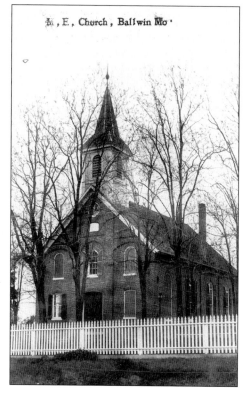

John Ball watched his little town grow slowly from its platting in 1837 until the time of his death in 1859. When he died, the community had 12 houses, a store, a tavern, and a blacksmith shop. Ball still owned 7 of the original 68 lots, plus a lot he had reserved for a Methodist church and another he provided for use as a cemetery. This photograph is of Salem Methodist, built by early German settlers, though it is unclear if the site is that provided by Ball. "It is the city's premier landmark," writes Esley Hamilton, "located at the top of the long hill leading up from the town of Manchester." The original 1870 sanctuary retains its dominant position in front of large modern additions.

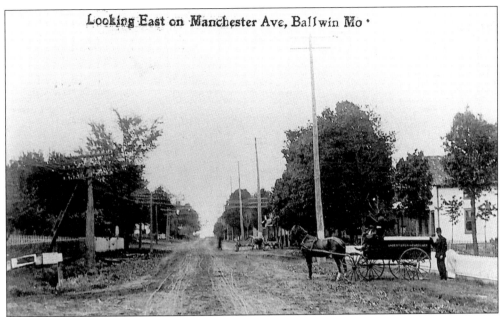

Looking East on Manchester Ave, Ballwin Mo .

Because Ballwin was bypassed by the railroads and did not sit on the Meramec River, its growth remained slow. The 1850 census listed 84 people in the little community, and in 1900, its population was only about 100. At this same time, the city of St. Louis was doubling its population every five years. Although Manchester Road was an important thoroughfare, at times its condition was almost impassible. One account in 1847 described portions of the route as "one continuous, almost unfathomable morass, so the horses sank into their bellies at every step." The photograph was taken around 1910 from the present-day intersection of Manchester and Holloway Roads, near the location of Schrader Funeral Home. Schrader's casket carriage is shown to the right with the words "Undertaker and Embalmer" on its side. Seen below is the Western Hotel, which provided lodging for travelers between 1876 and 1926.

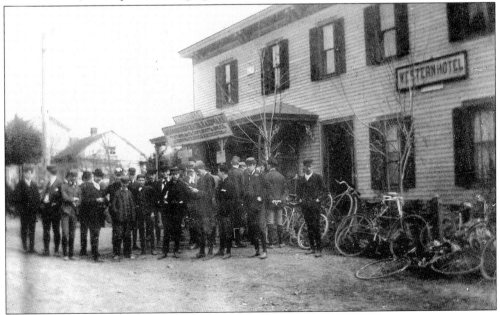

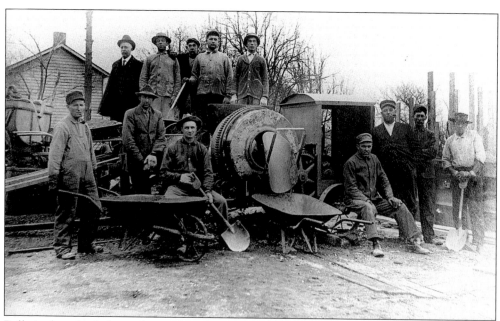

Ballwin benefited from the trades that the European immigrants brought in carpentry, cabinetmaking, bricklaying, and the like. Here, workers take a break from their efforts to rebuild Edward Blinne's store in early 1913; it had burned the previous year. Blinne was prominent in the community outside of his business, being elected to three terms as justice of the peace of Bonhomme Township. Blinne ran the store until his death in 1949. Blinne had purchased the business from Frederick Erke, who had operated the store from 1875 to 1903. The photograph below shows how the building looked around 1882. Erke and his wife, Wilhelmina (née Reinke), stand out front with five of their children, ones who were later lost during the scarlet fever and diphtheria epidemic that struck in 1886.

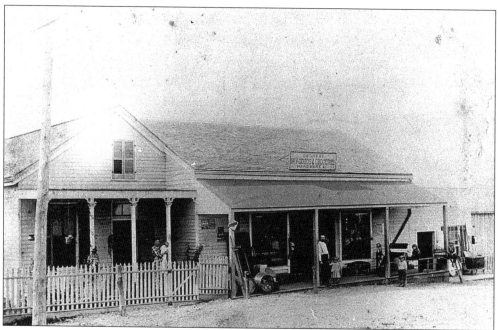

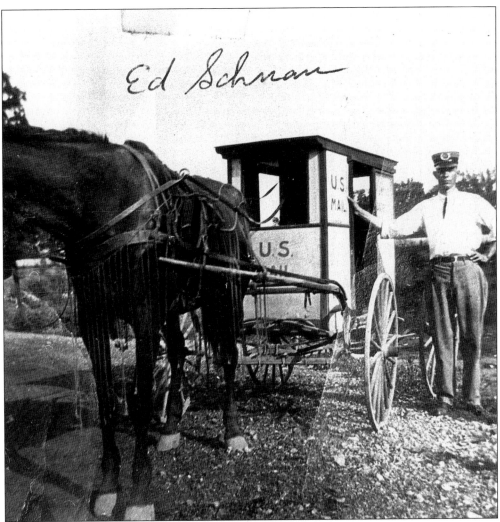

Ed Schnan

"Neither rain nor hail nor sleet nor snow nor heat of day nor dark of night" shall keep this carrier from the swift completion of his appointed rounds. Such determination is shown here by postman Ed Schnan. Ballwin was served by a number of postmasters, with Charles Peterson serving the longest, from 1917 to 1943. During most of that period, mail came twice a day, at 9 a.m. and 6 p.m. Arriving at Barrett's Station on the train, it was shuttled to Ballwin by John Bopp, who ran the bus line between there and Ballwin. Another business was the Ballwin Mutual Telephone Company, eventually taken in by Southwestern Bell. Back then, all residents on a particular stretch were connected to a shared line. One irritated resident discovered that his conversation was being listened to by one particular neighbor when the eavesdropper suddenly blurted out, "Oh, my beans are burning!"

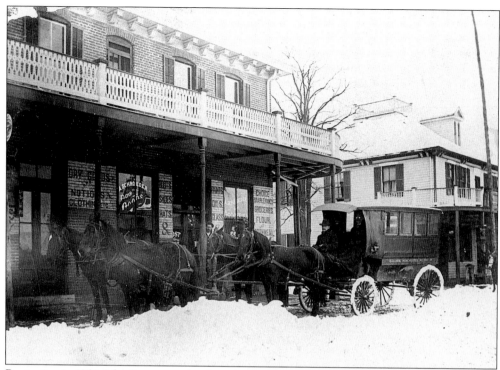

Beginning in 1901, John Bopp ran a bus line that ran between Ballwin, Manchester, and Barrett's Station, carrying mail and passengers. Bopp's first carriages were horse drawn. Normally, two horses were sufficient to pull it, but in snowy conditions (as seen in this *c.* 1910 photograph), two teams were needed. Bopp switched to horseless carriages (motorized buses) around 1920 and extended the route to Meramec Highlands and later into Maplewood, where commuters to St. Louis picked up the streetcar. After Bopp died in 1934, his daughter Helen took the wheel. She operated the route until her death in 1961.

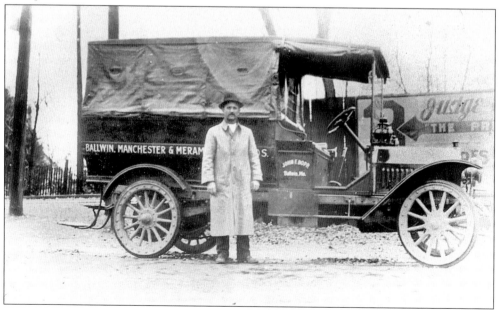

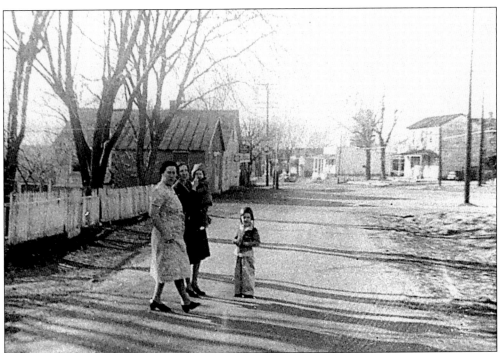

During the first half of the 20th century, Ballwin was a little town out in the country. Crossing Temple Lane above are Mrs. Julius Loehr and Mrs. Marshall Dubuque. Manchester Road is in the background, and the large white building in the back sits about where Station House No. 1 for the Metro West Fire Protection District sits now. The women and the two smaller buildings behind them are about on the present-day site of the Applebee's restaurant on Manchester at the Olde Towne development site. The license shown to the right allowed a man named Anton Kern to run a tavern located on property now owned by Salem Methodist Church. The Bonhomme Masonic Lodge used his building for meetings from 1896 (when they moved to Ballwin from Manchester) until they built their own structure in 1921.

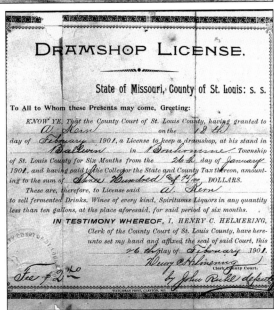

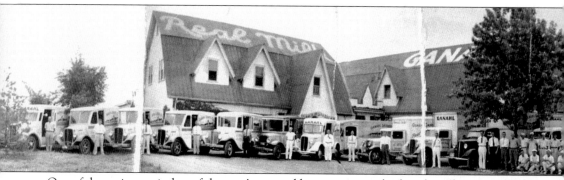

One of the major reminders of the area's pastoral beginnings can be found at Clayton and Kehrs Mill Roads. The twin spires of the Barn at Lucerne sit atop silos that belie its former use. First known as the Blue Grass Stock Farm, the property was owned by Henry Bopp, who built two brick barns on it in 1906, reportedly using bricks salvaged from the 1904 World's Fair. Bopp sold the property to Will Schisler in 1915. In 1916, Schisler established the Calla Lily Dairy Farm and erected the main dairy barn, office, and silos. The 50,000-foot barn was a modern marvel, with running water and electric lights. Doubtless, the cows were "mooved" by these luxuries to greater milk production. The property changed hands several times. It was purchased by John

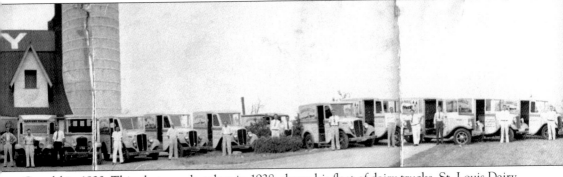

Ganahl in 1923. This photograph, taken in 1938, shows his fleet of dairy trucks. St. Louis Dairy took over in 1941, and after the operation was acquired by Sealtest, the barn was eventually shuttered. It sat empty for a number of years other than a brief stint as a museum for antique automobiles. A fire in 1968 marked a turning point in the property's renaissance. Recognizing the tremendous potential that remained in the site and the structure, Paul Londe (known to St. Louisans for his design of the Climatron at Missouri Botanical Gardens) led a redevelopment effort, renovating the building inside and out. The building reopened in 1974, hosting retail and entertainment destinations.

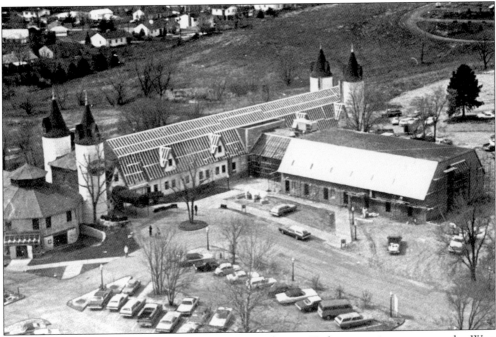

The Barn at Lucerne is seen here in a 1970s aerial view. Today a portion serves as the West County Education Center of the St. Louis Community College.

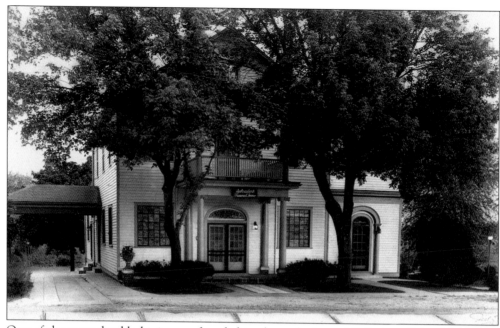

One of the most durable businesses founded in the early days of Ballwin is Schrader Funeral Home, still going strong after more than a century. Though William Schrader began in the funeral business "only" in 1894 as a partner to Louis Strothkamp, he learned part of the trade from his father, George F. Schrader, an immigrant to Ballwin from Germany in the 1840s. The elder Schrader was a carpenter who was known for his skill in making coffins. After 14 years in business together, William Schrader bought out Strothkamp in 1908. A fifth generation of the Schrader family operates the business today. The photograph above shows Schrader Funeral Home around 1920. Below, a Schrader Funeral Home carriage is being pulled in the 2000 Ballwin Days parade. Longtime employee Peggie Avery follows along in black, dressed in the widow's traditional mourning garb.

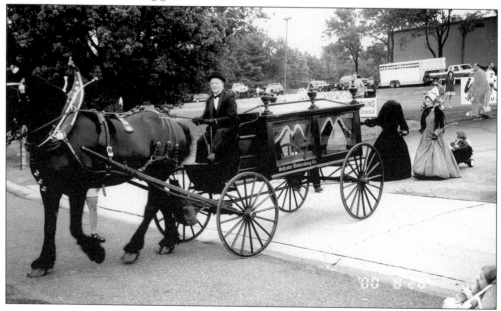

Gradually, the pace began to pick up in the little town. Route 66 ran through Ballwin for a half-dozen years on Manchester Road/Highway 100 prior to Watson Road being developed and designated as the permanent route for those travelers getting their kicks on Route 66. The increased traffic through the area from November 1926 through December 1932 was a portent of things to come. Today, signs mark the route of that historic highway.

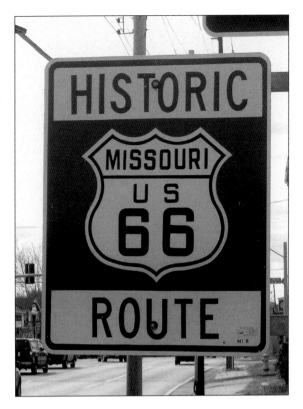

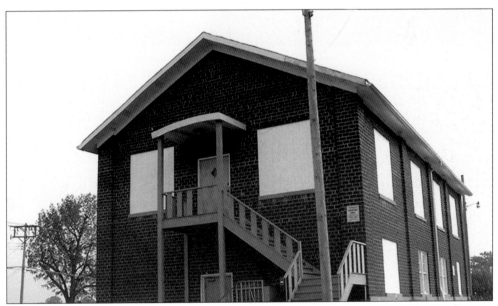

Other new construction showed that the community was indeed growing. The Bonhomme Masonic Lodge, first established in Manchester in 1841, decided to build a new structure. They purchased a lot on Manchester Road and erected this building. Its prominent location atop the hill nearly opposite Salem Methodist Church made it a landmark for many years. The building was demolished during the Olde Towne redevelopment project in 2000.

During the 1930s, a group of Ballwin men formed a birthday club that met at the Red Cedar Inn in Pacific, Missouri, after the repeal of Prohibition. The group was formed for fellowship and tried to balance itself at 12 members, with one having a birthday each month to round out the calendar and give them a reason to celebrate. Pictured from left to right are Ted Schrader (Schrader Funeral Home), "Nig" McDaniels (tavern in Castlewood), F. X. Essen (Ballwin Motor Company, Chevrolet dealer), Frank Lindemann (nursery, Manchester), Fred Rethmeier (decorator), Hy Koch (Ballwin farmer), John Streiff Sr. (chair, Ballwin's first board of trustees), Harry Schrader (Schrader Funeral Home), Bill McKinnon (Ballwin Hardware), and Ralph Huber (Manchester Nursing Home). Not pictured is another member of the group, Dr. Hy Scott, general practitioner. (Photograph courtesy Don Essen.)

Two

A NEW COMMUNITY

Following the end of World War II, GIs by the thousands returned home, got married, and started families. The automobile made the suburbs possible and brought rapid growth to Ballwin. Soon the fields ringing the town no longer sprouted corn or hay, but houses. Community leaders began to consider incorporation. They saw advantages to creating a formal, localized government, most notably in the ability to create effective zoning laws and to react to the needs of Ballwin residents with responsiveness. This photograph shows the first village board of trustees. From left to right are the following: (front row) Henry Woerther, John Streiff (chairman), and Edgar Boedeker (city attorney); (back row) Fred Rethmeier, Henry Rasch, and F. X. Essen. At the time of the incorporation in December 1950, Ballwin's population was only 850 people and the incorporation covered an area of just two and a half square miles.

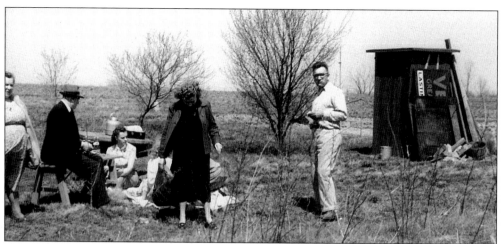

Peter and Emma Lapins were one of those young couples who left the city for the suburbs. This photograph shows an early visit to the plot of land at 318 Ries Road (now 352 Ries Bend Road, after the realignment) that would become their home. "We purchased two acres of land in far west county on Ries Road in the fall of 1954," recalled Emma Lapins. "My husband, Peter, and I were newlyweds living in the city of St. Louis. We wanted to build a house and have children, a house in the country with room for beehives, fruit trees and a large garden. Seeking their approval, we invited friends and family out to the property for our first picnic. During the following season, they returned to help us build the home where our family lived for over 45 years." Peter Lapins is the taller man with dark hair in the center right. (Photograph courtesy Emma Lapins.)

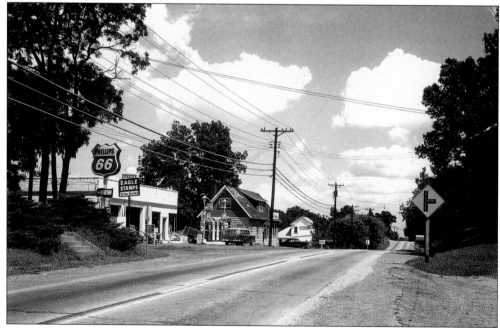

Manchester Road was still a two-lane road and barely a wisp of what it is today. This photograph was taken looking east from a vantage point directly opposite Salem Methodist Church. The service station was run by Isador Marcus. The building in the center was the Rock House liquor store.

24

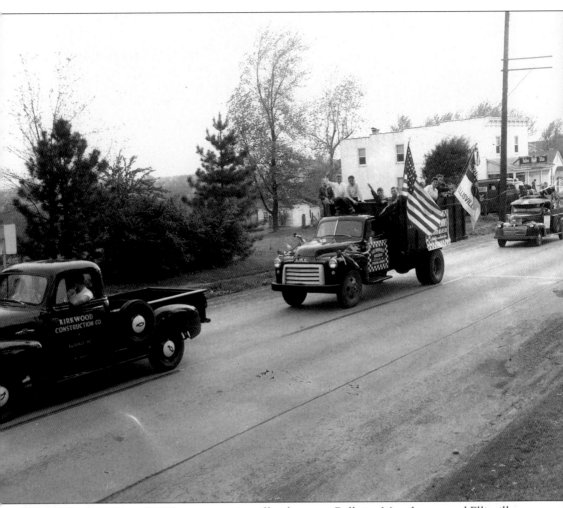

Around this same time (1955), a cooperative effort between Ballwin, Manchester, and Ellisville led to the installation of electric streetlights, an event marked by the parade shown above. This early event is just one of many examples of the collaboration that has taken place between the communities over the years. Though occasional calls for merger have come forth, offering the usual arguments about economies of scale, duplication of services in city governments, and so forth, the cities have remained independent. The cooperation continues, including Winchester, a tiny municipality squeezed between Ballwin and Manchester. The name Winchester was formed by combining the last parts of *Ballwin* and *Manchester*.

As the town grew, so did its sense of community. Younger families joined ones who had been in Ballwin for generations, and a number of new social and civic organizations flourished, including the Lions and Jaycees. One testament to the stability of a town is found in tenure of its residents. Here are before and after photographs of the leaders of the Ballwin Jaycees. The first was taken in 1961, the second in 2001. In the above photograph are, from left to right, Duff Rick, Art Macalady, Larry Kokesh, Kirby Baldwin, and Dick Andrews. Seen below are, from left to right, Duff Rieck, Kirby Baldwin, Bob Pisarkiewicz, Ken Velton, Dick Andrews, and Bob Seymour. (Photographs courtesy Carol Baldwin.)

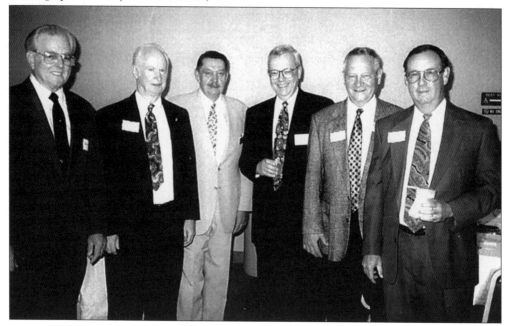

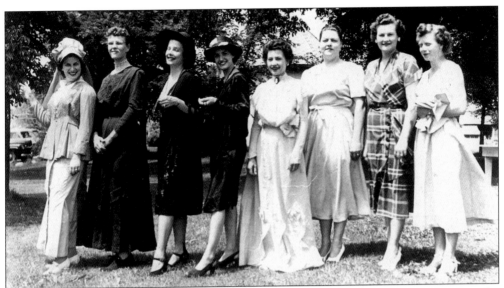

Ballwin's first fashion show took place in 1960. It was part of the festivities to commemorate the 10-year anniversary of the city's founding. These women dressed up in period clothing—fancy dresses and hats from yesteryear. Picture from left to right are Ruth Arft, Charlotte DuParri, Pat Essen, Louise Dahlke, Clara Trog, Lucille Baumer, Jerry Edmundson, and Margaret Trog.

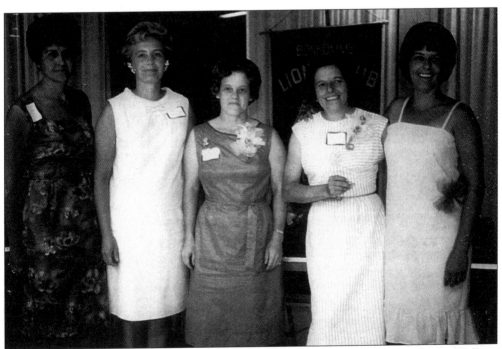

Women's groups during that time included the Tuesday Contemporary Club, the Ballwin Homemakers Extension Club and the Bonhomme Lady Lions. The Lady Lions were an auxiliary of the Lions Club, whose membership was restricted to men at that time. Here is the installation of the officers of the Lady Lions around 1964. From left to right are unidentified, Carol Baldwin, Evy Steinbrueck, Jackie Link, and Nancy Babbit. (Photograph courtesy Carol Baldwin.)

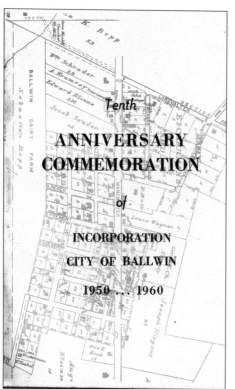

Tenth

**ANNIVERSARY
COMMEMORATION**

of

**INCORPORATION
CITY OF BALLWIN**

1950 ... 1960

In just 10 years, Ballwin grew from a little burg of only 850 residents to a booming town with over 5,700 citizens, an astonishing growth rate of 670 percent. Ballwin marked this 10-year milestone with a gala celebration, featuring a ceremony with a number of speeches and distinguished guests, a parade, baking contests, and a dance. Girl Scouts served as color guard for the ceremony and marched in the parade that followed. A dedication in the program emphasized that the events honored not only what had taken place but what was to come: "This booklet is dedicated to the future leaders of Ballwin. In 1950 was seen unfolding an opportunity to grow and expand out boundaries, enterprises and citizenry. Today in 1960 the opportunity can be further realized by the selfless integrity of aspiring, devoted community servants. To this end we hopefully dedicate the following pages." —Patricia E. Essen.

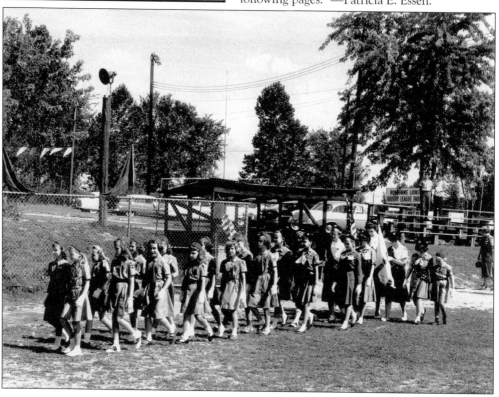

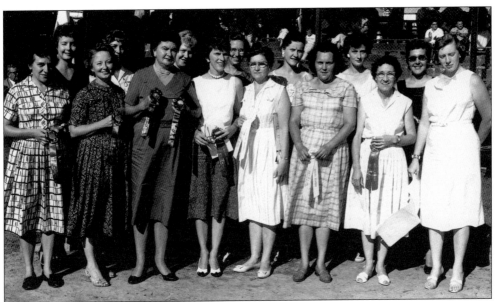

The celebration featured a number of contests. Above are some of the women who took home awards in the baking contest. From left to right are the following: (front row) Violet Wissman, unidentified, Theresa Schlager, Barbara Wood, unidentified, unidentified, Stella Thurmond, and Marge Canterberry; (back row) Pat Essen, Dorothea Bante, Ruth Rasch, Veneta Crosley, Norma Kraus, Pat Zinke, and Wilma Stortz. Mrs. Clifford Kraus organized the contest and bake sale. Her father-in-law, Roy Kraus, operated a grocery store in Ballwin for many years after buying the shop from Edward Blinne. The celebration's finale, a square dance, took place at the Ballwin Athletic Fields. George Peters was the caller.

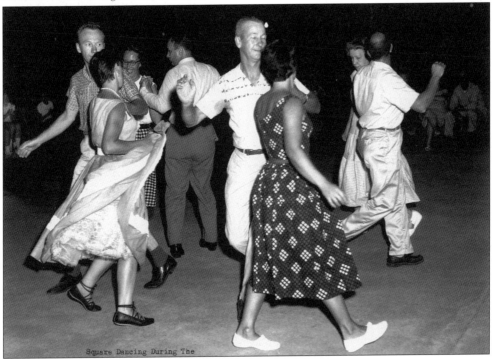

Square Dancing During The

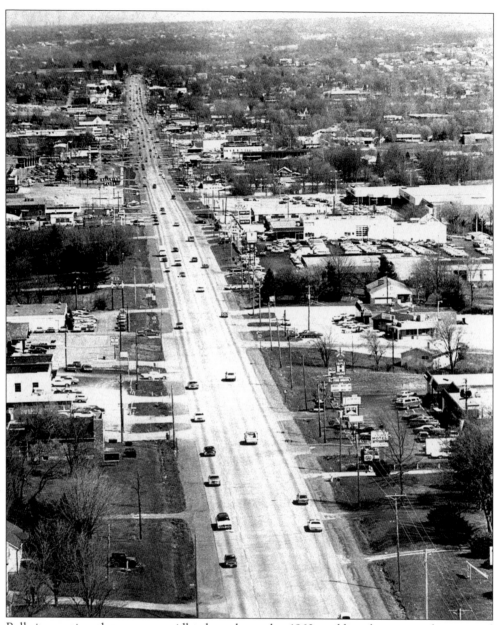

Ballwin continued to grow rapidly throughout the 1960s, adding businesses, homes, and civic organizations. One civic group was the chamber of commerce, which was formed after F. X. Essen, founder of Essen Chevrolet, realized the value such an organization might offer. Essen contacted businessmen from the area, including Ellisville and Manchester, about the possibility of forming a chamber. By May 1957, the Lafayette Chamber of Commerce had been officially chartered to "promote, advance and develop the commercial, industrial and civic interest of the area." Their first major project was the widening of Manchester Road/Highway 100 through the area. For nearly five years, they worked to convince the state highway department that a four-lane thoroughfare was necessary. This eastward view shows Manchester Road after the widening was complete in 1963. Ballwin Plaza is on the left side of the picture about two-thirds of the way up. Salem Methodist Church is visible at the top of the hill.

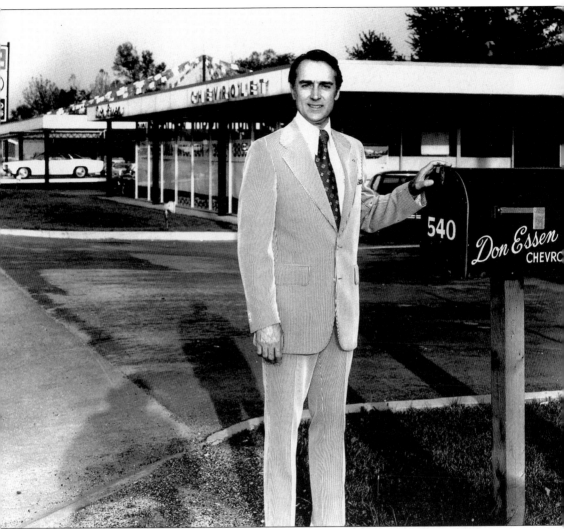

Among the businesses that anchored the thriving commercial artery along Manchester Road and put the city on the map to the outside world was Essen Chevrolet. This durable dealership was started in 1922 as Ballwin Motor Company by F. X. Essen, who had come to Ballwin as a mechanic to repair automobiles just three years before. He changed the name to Essen Chevrolet and ran the company until 1949, when his son Don took over management. The company became known as Don Essen Chevrolet in 1954 and continues today as ELCO Chevrolet at the same Manchester Road location. "I executed a sales agreement to sell the assets of Don Essen Chevrolet to Enterprise Leasing Oct. 29, 1985," recalls Don Essen. "The Taylors subsequently incorporated as ELCO Chevrolet, using the first letters of the leasing company name. My contract would have expired in 1986 and I did not have a son or successor designee, so our family decided to sell after 63 years of operation. It was a difficult decision." (Photograph courtesy Don Essen.)

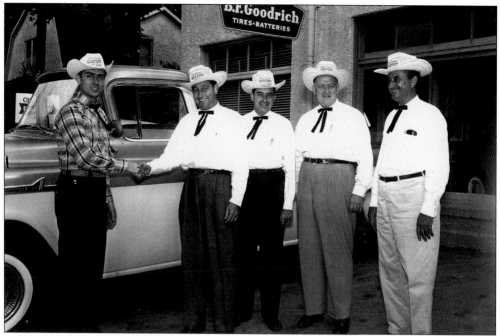

Essen used cutting-edge techniques to promote the dealership. He printed monthly newsletters, hired models, and experimented with a 24-hour service department. His neon "daisy" sign marking Essen Chevrolet was a landmark for decades. Here, Don and his staff wear cowboy garb to tie into his "Way Out West" promotion. He is on the far left. Next to him is Doyle Cox, who was the head of new car sales. At the far right is Ed Schmidt, who managed the used car department. Of the two salesmen in the middle, the one on the left is unidentified. The one on the right, next to Schmidt, is Bill Walsh. (Photograph courtesy Don Essen.)

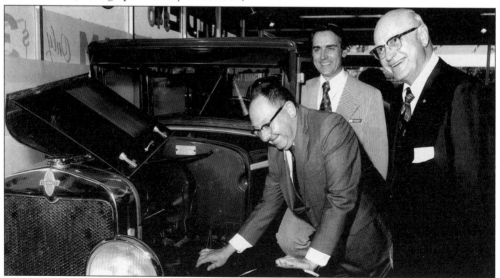

Essen Chevrolet marked its golden anniversary—50 years in business—in 1972. Here, F. X. Essen, one of the leaders of Ballwin's 1950 incorporation, stands with son Don. With them is Roland Wussow, who worked 44 years for the dealership. Wussow had worked on that 1929 Chevy he is leaning over when it was new. (Photograph courtesy Don Essen.)

Three

GROWTH AND DEVELOPMENT

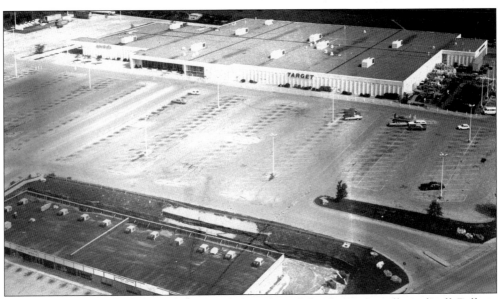

During the 1960s and 1970s, commercial and residential development really took off. Ballwin Plaza opened in 1962, and the Target Plaza, set back from Manchester Road at the corner of Manchester and Holloway, opened in 1970, when Ballwin's population hit 10,600, an approximate doubling in 10 years. A 1973 analysis of the city's population performed by Campbell and Associates showed that almost half of Ballwin's population had moved into their present homes since 1965. The study offered commentary on this amazing period of growth and the types of people making up the core of this young city: "The people are likely to be upwardly mobile in social status and striving for further achievements. Most will hold a strong work ethic . . . The income levels are much higher than the state average, and somewhat higher than the county. This higher income is reflected in a large proportion of home owners."

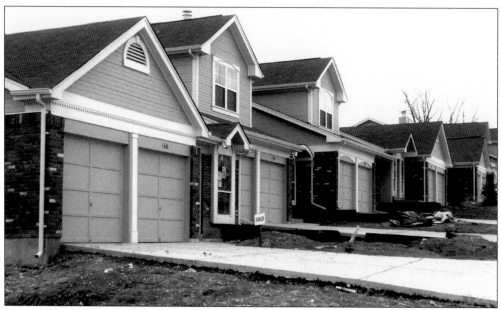

Though the community is now mostly developed, builders were busy in Ballwin for decades, putting up new homes and businesses. New residential construction meant lots of Sold signs; businesses added shopping options for residents. These photographs from the spring of 1986 show new homes going up in the Kehrs Mill Crossing development, west of Vlasis Park off Kehrs Mill Road, and a new retail complex under construction on Holloway Road near Manchester, home to John Pils Studios. Mille Wallace writes, "I'm glad that new people came into this town and loved it so that they made it grow and became settlers, in a manner of speaking, just like my great-grandparents who came to Ballwin in the 1800s."

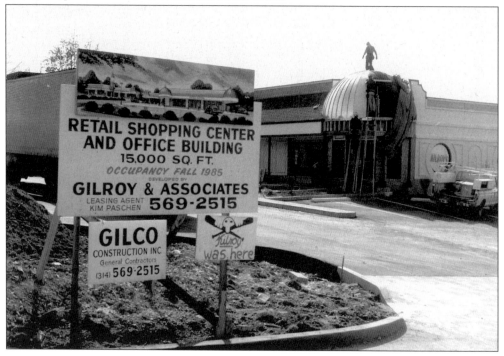

The Lafayette Chamber of Commerce, now known as the West County Chamber of Commerce, has been a strong advocate for area businesses for 50 years. One popular event has been the business fair/trade show, where local merchants can set up displays, allowing the public the chance to see in one place all that the business community has to offer. New homes going up meant lots of business for these Century 21 Realtors, and the 1985 business fair held at Lafayette High School offered them the opportunity to introduce themselves to potential clients. The 1985 trade show also featured exhibitors marketing a technological marvel, a "cellular car phone," one that "anyone could afford," as well as satellite television, another new and novel item. (Photographs courtesy West County Chamber of Commerce.)

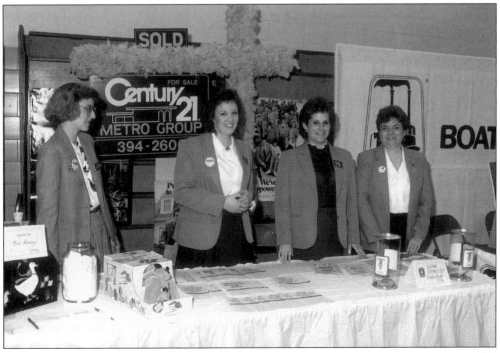

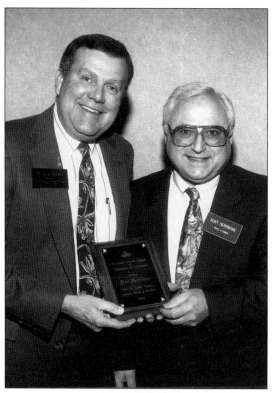

Ballwin businessman Kurt Herrmann (right) of Triple H Farms was recognized as the West St. Louis County businessman of the year in 1992. Presenting him with the award is Philip Folsom, president of the West County Chamber of Commerce that year. Triple H Farms was a major sponsor of a popular hole-in-one contest over three weekends in July 1983. The prize was $10,000 for anyone who could put it in the hole with one shot. The event was organized by the West County Chamber of Commerce. Below, Denver Radford receives a plaque of appreciation for his effort during his term as president of the chamber in 1968. Radford also operated a barbershop in Ballwin Plaza. With him is Frank Hairston, an insurance agent with State Farm. (Photographs courtesy West County Chamber of Commerce.)

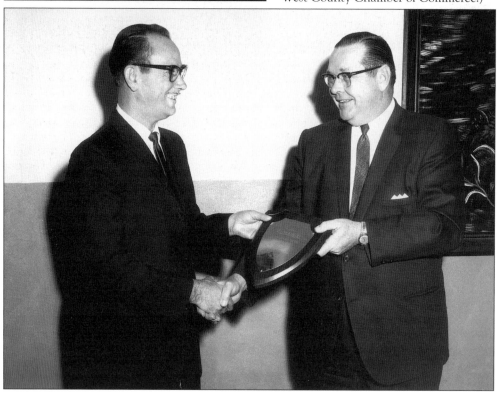

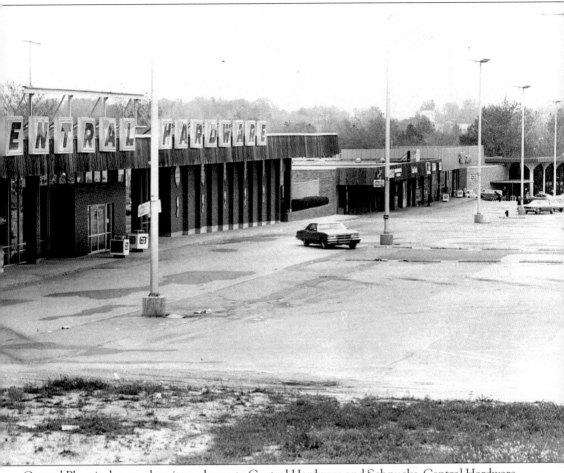

Central Plaza is shown when it was home to Central Hardware and Schnucks. Central Hardware went defunct in the early 1990s, and the Schnucks grocery store in this picture moved to Ballwin Plaza in 1988. A Borders bookstore now sits as a major tenant anchoring the site on Manchester Road. The importance of this commercial corridor is hard to underestimate. The 1 percent sales tax, which went into effect in 1970, has been a boon to the city, providing the largest (40 percent) portion of its operating revenue. "We realized there was a strong source of funding there about the time Target came in," says Jon Bopp, mayor from 1971 to 1977. "It allowed us to issue a $3 million bond in 1973 for street improvements with no tax increase. That bond paid for street widening, putting in curbs, gutters and sidewalks along with moving utilities and storm water drainage underground." In 1987, Ballwin eliminated its property tax. It is one of a few St. Louis County municipalities that have no city property or personal property tax.

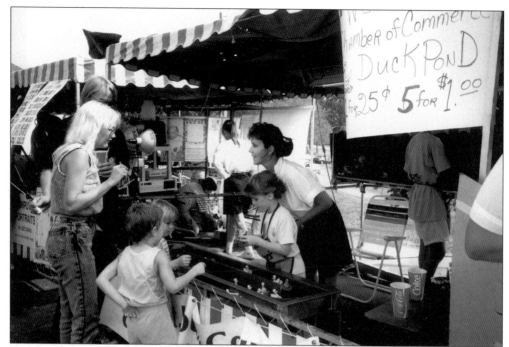

Business members of the West County Chamber of Commerce also give back to the community by their involvement in various events, including fundraisers such as golf tournaments, trivia nights, and more. In this photograph, members man a duck pond booth at Ballwin Days. (Photograph courtesy West County Chamber of Commerce.)

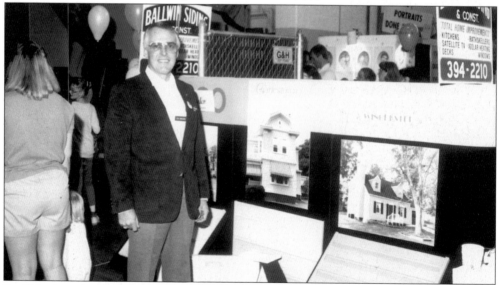

Small business has been at the heart of Ballwin since the earliest days of general stores. Ballwin Siding and Construction has been in business since 1978. Owner Ed Brame was recognized as the national contractor of the year in 1996 by the National Association of the Remodeling Industry. In 1997, Mayor Ed Montgomery issued a proclamation establishing Ballwin Siding Days. Ballwin Siding has been involved in the recent restoration project for the Old Ballwin School. (Photograph courtesy West County Chamber of Commerce.)

Ballwin struggled with balancing commercial development and historical preservation when it came to the original heart of the community as laid out by John Ball in 1837. The roots of the Old Towne redevelopment project went back to 1980 or earlier, when Ballwin 2000 was introduced as a master vision for the city's growth and development, calling for massive redevelopment along Manchester Road. These photographs are from mid-2000, before any redevelopment work began. In the view below, the building at the top of the hill is the Masonic Temple, built in 1921. All of the buildings on the right were consumed by the new project, including the building that housed the Coach House restaurant, built in 1870 as a residence for physician Charles B. Zeinert.

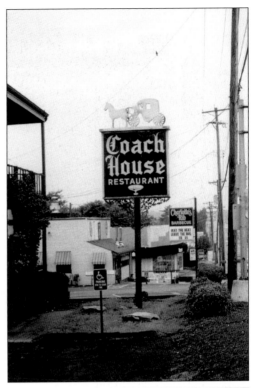

The project was controversial to some, as it would obliterate the oldest part of Ballwin. A group called Citizens for a Better Ballwin protested, urging the city to protect its historic structures. "Where will the heart of Ballwin be if Old Towne is wiped out?" Elm Street resident Cindy Overton asked. Bob Pisarkiewicz, alderman from 1974 to 1998, said he and the board saw it as a necessary step. While the design of the streets there was okay for 1837, they did not pass muster 150 years later. Two of the streets John Ball carved out are shown here. Elm Street is shown above in a view looking toward Manchester. The steeple of Salem Methodist Church is behind the second white house. Main Street is shown below in a view looking west from the corner of Elm near Ballwin School. The house farthest back was owned by the Buermann family and was built around 1870; the Hellmann and Trog families lived in the other two homes.

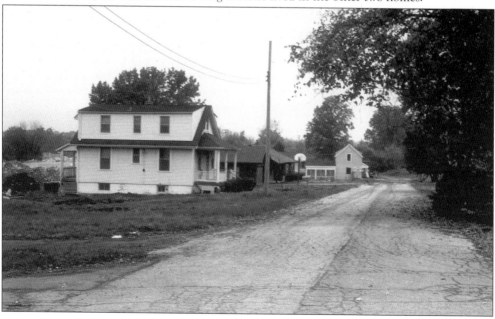

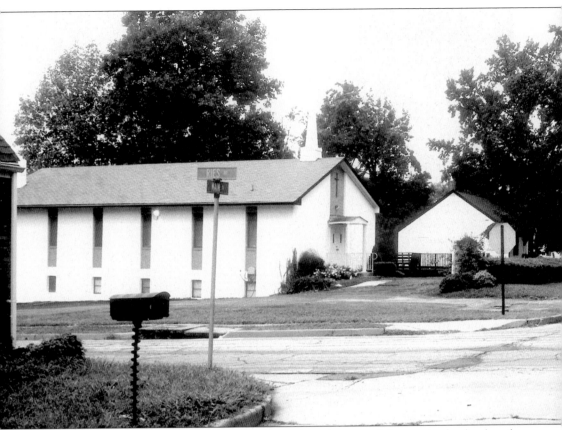

The First Missionary Baptist Church of Ballwin stood on the ground that was to be developed. Along with some of the oldest homes in Ballwin, this historic black church was razed in fall 2000. The church had its last service on September 16, 2000. Here is the church as it looked, standing at the corner of Ries and Main. Even though this forced relocation was especially difficult, Pastor Richard Rollins said the church was blessed by the support it received from the community, especially from other churches. "During the transition our church will conduct services at several local churches and our administrative offices will be relocated within the Ballwin community," said Rollins. "Manchester Baptist Church, Ballwin Baptist Church, New Hope Baptist Church and Ballwin Elementary School will be used for weekly bible study, fellowship, meetings and Sunday services, respectively."

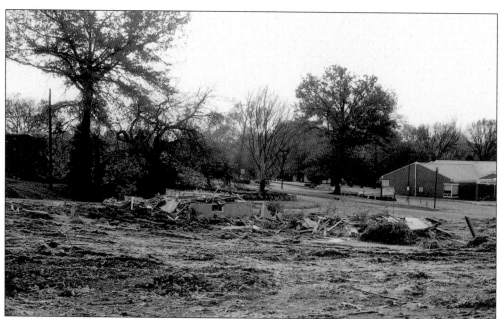

Demolition of the houses began in fall 2000. What was once a home directly across from Ballwin Elementary is a pile of rubble in the top photograph. The $55 million commercial development project, known as the Olde Town Plaza, was supported with about $13.6 million in tax-increment financing (TIF) funds. City officials expected it to generate about $630,000 in total annual tax revenue. In order to raise the retail development to a level more closely aligned with Manchester Road, builders moved thousands of tons of dirt and rocks to raise the elevation of the lot. The bottom photograph shows the beginnings of that hill on which the retail complex was constructed. It would become so tall that it would eventually block the school from view. Even in this photograph, taken in October 2000, only the metal peaks of the roof are still visible.

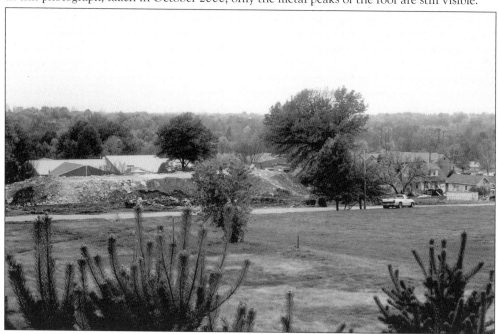

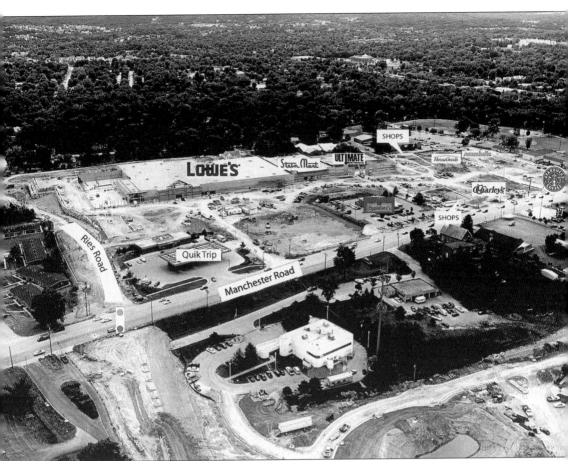

Provided by the developer Regency Centers, this photograph shows the work in progress in August 2001. In addition to the construction on the south side of Manchester Road in the top of the photograph, note the parallel work to the north, including the new roads being built into the city government center, the new lake being installed in Vlasis Park, and the realignment of the intersection of Ries Road and Seven Trails Drive. This photograph was taken just four months before the three major tenants of the Olde Towne Plaza—Lowe's Home Improvement, Stein Mart, and Ultimate Electronics—were scheduled to be open, by December 1, 2001. The remaining anchors, Marshall's and Home Goods, and other smaller tenants planned openings in the first quarter of 2002.

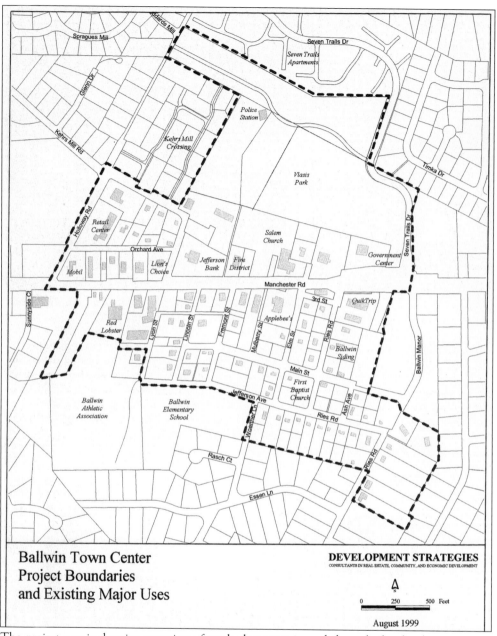

**Ballwin Town Center
Project Boundaries
and Existing Major Uses**

DEVELOPMENT STRATEGIES
CONSULTANTS IN REAL ESTATE, COMMUNITY, AND ECONOMIC DEVELOPMENT

0 250 500 Feet

August 1999

The project required major rerouting of roads that went in and through the development area. A new Jefferson Avenue, built to access Ballwin Elementary and the Ballwin Athletic Fields, travels behind the project. Ries Road was also realigned to intersect with Seven Trails Drive. Lyons Avenue received a new name, Ballpark Drive. A number of other streets disappeared completely, including Elm, Ash, Mulberry, Fremont, Lincoln, and Main, all narrow drives that crisscrossed the heart of Old Ballwin. This map, done for the city by Development Strategies, a St. Louis consulting firm, shows the old town section with businesses existing prior to redevelopment, overlaid with the outline of the TIF area. The new retail center encompassed everything south of Manchester Road to Jefferson/Ries Road and from Lyons to the eastern boundary.

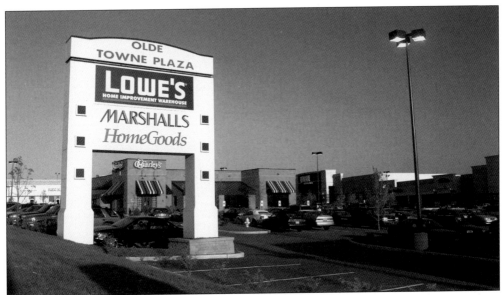

Olde Towne Plaza, with first sections finished in 2001, covers approximately 287,700 square feet. It was built over 32 acres. Ballwin's progress was recognized in July 2005, when *Money* magazine included the city on its list of the 100 best places to live. The magazine analyzed more than 1,300 towns with a population of at least 14,000 people, making its selections based on economic, education, and safety factors. Housing affordability, taxes, and real estate appreciation were all considered, as were environmental factors, education, culture, and weather. The survey showed Ballwin's median household income ($75,739) to be higher than the average ($68,160) of the other places on the list. Another strength is in the city's affordable housing stock. The $201,209 average home price in Ballwin was much lower than the best places average of $316,665. (Photographs courtesy Regency Centers, developer for the Olde Towne project.)

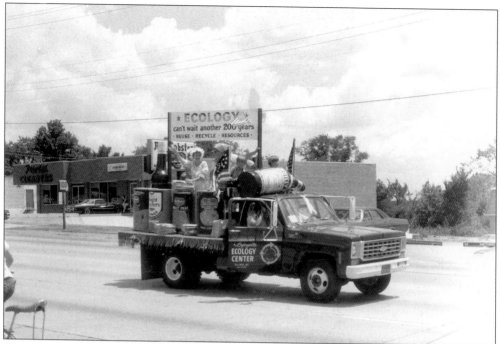

Even prior to the energy crunch days of the 1970s, Ballwin was aware of the impact smart recycling and energy management programs can have. In 1974, the Lafayette (now West County) Chamber of Commerce and West County Jaycees established an ecology center to promote reuse and recycling as well as conservation of our natural resources. To promote green living, the groups even ran the float pictured above from the ecology center in the 1976 bicentennial parade.

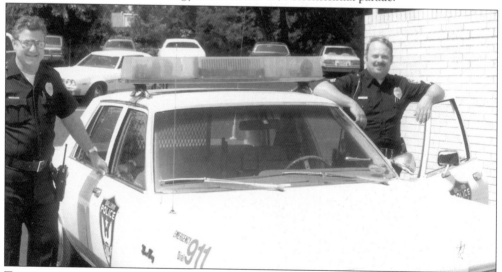

To trim consumption in the 1980s, computers installed in Ballwin police cars monitored officers' driving patterns. The device promised a 10 percent savings in fuel consumption. This August 1982 photograph shows reserve officer Harry Wangrow (left) and retired sergeant Jim Srote. Wangrow, later the chief of police in Winchester, died in 2003. His widow Peggy is communications supervisor for the Ballwin Police Department, and his son Dave Wangrow is a current officer on the force.

The ecology center was located on the west end of the Target parking lot. Recyclables were sorted by material type and reprocessed, rather than just being thrown away. Today, a special clause in the city's current trash collection contract provides curbside pickup. Each home can get a free 14-gallon plastic bin for recycling newspaper, glass, plastic, aluminum, and more.

Ballwin's 1984 city calendar offered energy-saving tips for residents. The calendar cover is shown above; seen below are the tips offered in July. The city has always been conscious of its role in setting the example in energy conservation. For example, the energy crisis in the early 1980s prompted the city officials to modify police cars to run on propane and install solar heating panels in city offices. At the same time, using a $27,000 federal grant, the city hired an energy coordinator, Barry Moline, to help exploit possibilities for saving energy.

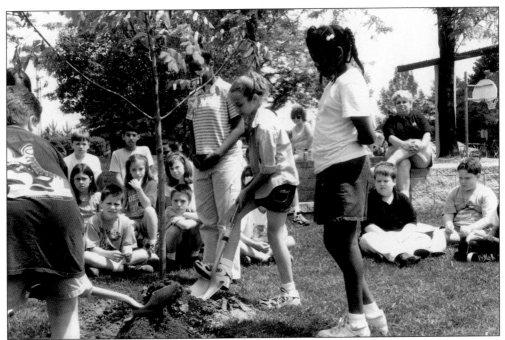

Ballwin has been designated as a Tree City USA since 1991, an award given by the National Arbor Day Foundation and the Missouri Department of Conservation. One of the criteria for this award is that at least $2.00 per capita must be spent on tree care each year. In 2003, Ballwin spent $9.29 per citizen. In the top photograph, fourth graders from Woerther Elementary plant a tree in New Ballwin Park for Arbor Day in 2000. In the bottom photograph, St. Louis District forester Rob Emmett (center), an employee of the Missouri Department of Conservation, attends the tree-planting ceremony and speaks to the kids about the history of Arbor Day. He is joined by Smokey the Bear and parks and recreation director Linda Bruer.

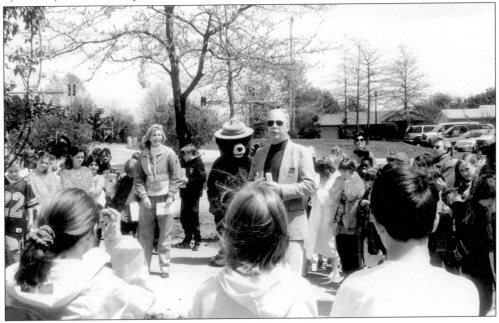

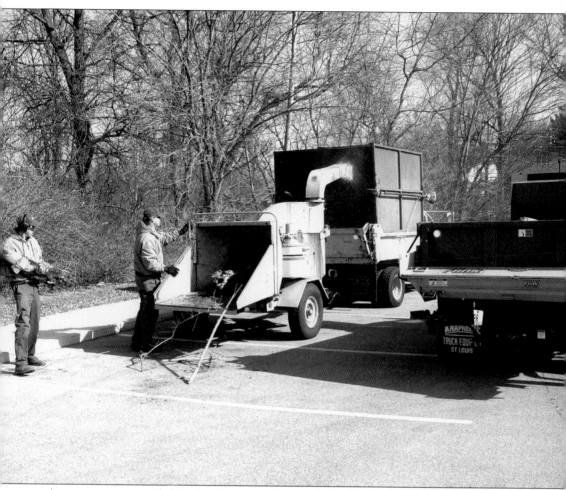

A great service provided by the city to residents and the environment is wood chipping, done by employees of the parks and recreation department. Here, Dan Trower and Rob Vineyard feed brush and smaller logs into the chipper. The chipper shreds the wood, and a tub grinder turns it into mulch, which is then returned to residents for landscaping. In 2003, city work crews picked up about 2,700 cubic yards of brush from 815 Ballwin homes. This was converted into 385 yards of mulch, keeping it out of landfills and providing a valuable material for residents. Additionally, Midwest Waste hauls leaves free of charge from the city to a composting site. In 2004, over 10,000 cubic yards of leaves were collected and turned into compost. That is the area the size of a football field covered nearly eight feet high with leaves.

Four

SERVICE TO OTHERS

One of the reasons for Ballwin's incorporation was that city leaders saw the need to provide basic civil services. An effective police force is part of this, of course, and Fred Rethmeier was appointed as marshal in 1950 by virtue of his role as a city trustee. The job became an elected position in 1957, and the first in office was Herman Baumer, who fixed up his car with a siren and red lights he paid for himself. His wife, Lucille, would turn on their porch light at home to signal him whenever there was a call. Eventually, Baumer installed a radio in his house, and Lucille took calls and relayed them to him that way. Ballwin bought its first police car in 1958, and it was used by Baumer and four part-time officers who rode in the evenings.

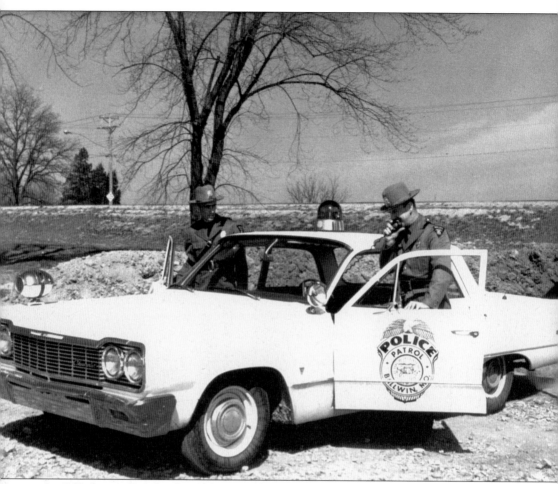

In 1959, the city hired its first full-time officer, George Arft. Residents voted in 1963 to eliminate the elected office of marshal and instead create a police chief, making it an appointed position. Philip St. Onge, a former St. Louis County sergeant, was the first to serve in this role, appointed by Mayor Walter Smith. After St. Onge resigned, Ballwin native Donald "Red" Loehr took over in 1965. Here, Loehr stands with officer Don Easter, ready to respond to a call.

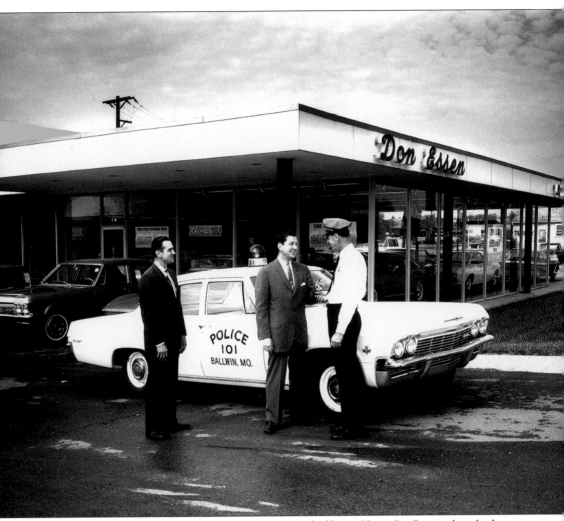

As Ballwin grew, so did the department, adding cars and officers. Here, St. Onge takes the keys to a new cruiser from Frank Kiddo, sales manager of Essen Chevrolet, in May 1965. Don Essen stands to the left. (Photograph courtesy Don Essen.)

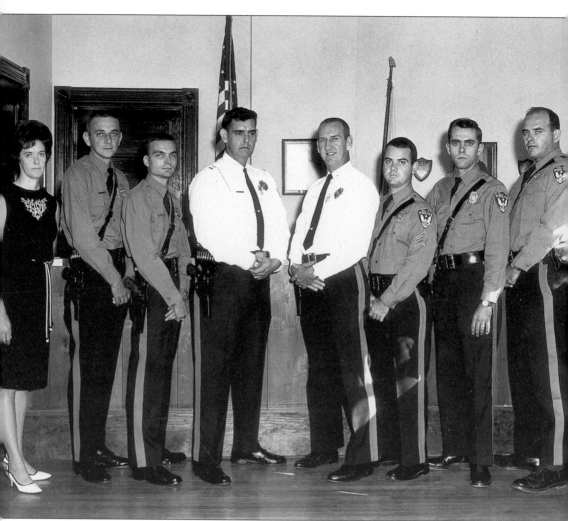

Here is the complete Ballwin Police Department in the mid-1960s after Loehr took over. From left to right are Lee Akers, Don Gockel, Bill Rauscher, Dave Beckett, Don Loehr, Wayne Rambaud, Mark ?, and Edward Dunn. Four dispatchers were hired in 1967 to handle the increased number of calls coming from the growing city. In 1970, with 12 full-time officers and four cars, the department moved into new facilities at 300 City Hall Drive.

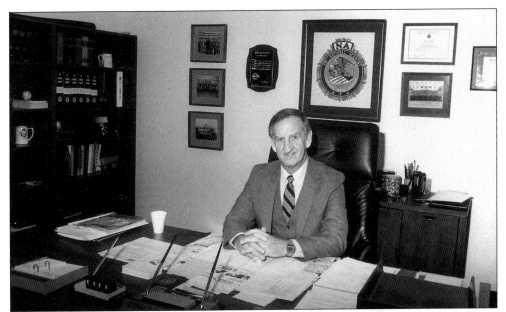

After a stint in the U.S. Navy and with the St. Louis Cardinals organization in the 1950s, Donald "Red" Loehr joined the department in 1961. He was promoted to sergeant in 1963 and selected as chief two years after that. Loehr served in that role until he retired in 1995 after 30 years in office. He died in 1997.

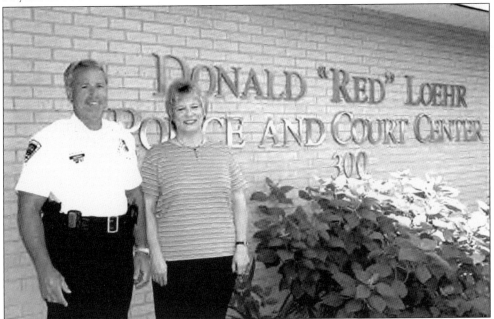

Following Loehr's retirement, Jim Biederman was named chief of police. Biederman joined the department in 1977 and was promoted through the ranks before assuming the top post in July 1996. Biederman was honored in 2004 as the Donald "Red" Loehr Outstanding Police Chief of the Year, an award given by the Missouri Police Chiefs Association. In this photograph, he stands with Loehr's widow, Glenda, a Ballwin city employee, in front of the building named for her husband.

Ballwin police have always placed a great deal of emphasis on the importance of positive interaction with the public. Here officer Michael Barnett gives "driving tips" to Andre Castiaux as part of a bike rodeo conducted by the department. These events offered kids a chance to have fun and learn the rules of the road. Additionally, bikes in Ballwin can be registered with the department to aid in recovery if stolen.

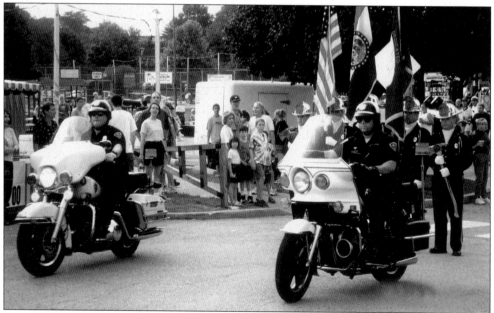

Ballwin police began using motorcycles to patrol in 1974. They are effective at maneuvering through traffic and can get to places sometimes inaccessible to patrol cars. Here, patrolmen George Boswell and Dale Tucker work the 2000 Ballwin Days parade, ready to lead the units stepping out behind them. They are followed by the Metro West Fire Protection District color guard.

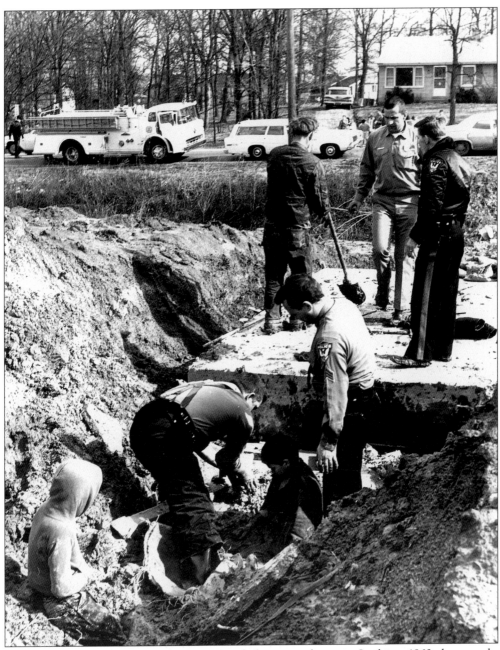

Sometimes the involvement with community kids is more dramatic. In this c. 1963 photograph, members of the Ballwin Police Department join with the Ballwin Fire Protection District to extract two boys from the mud. This was on New Ballwin Road, near Morgan Selvidge Middle School. What looked like semi-solid ground was instead a deep mud hole. One boy (left) is stuck in the muck in over his knees. The other is in to his waist. "The kids were playing and tried to cross the mud area by a sewer pipe," recalls former Metro West fire chief Jim Silvernail. "Both were gotten out with no injuries." Dick Hall stands in the back right, facing the action. Ray Trog is the firefighter in the hole, bent over and facing away from the camera.

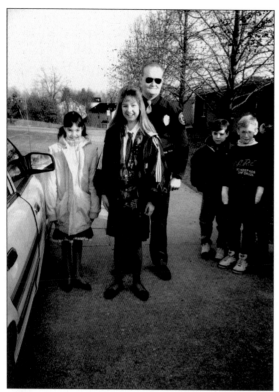

The Ballwin Police Department maintains a strong emphasis on community and reaching out to kids. Ballwin police officers teach classes on criminology at the junior and senior high school levels. Fifth and sixth graders at all schools in the department's jurisdiction receive drug abuse resistance education (DARE). In the photograph to the left, Woerther students Julie Wikete (left) and Melissa Voigtmann stand with Sgt. Kevin Scott of the Ballwin Police Department in 1994. They are getting ready to go to city hall to see government in action. Buckle Bear, seen below, visits younger kids at schools, encouraging kids to use seat belts. With him are officer Bobbie Baumgarth and Chief Loehr.

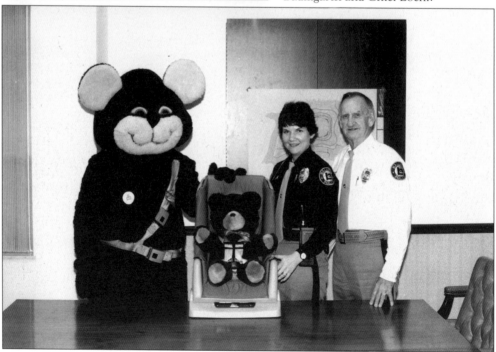

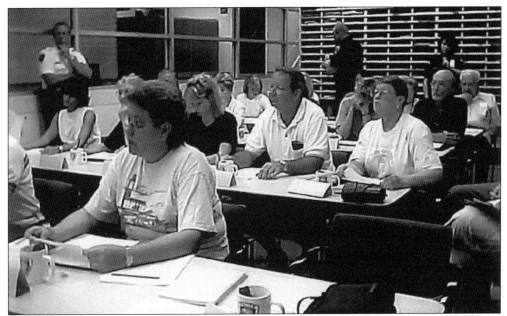

The Ballwin Police Department has implemented a number of innovative approaches to policing the community over the years. One of these is the Citizens' Police Academy, a 10-week program that started in 2000. In each session, 25 participants receive a look into the operation of the department and how law enforcement works. Participants take part in classroom training (above) but get a lot of hands-on activity, too, including firing weapons at a shooting range. In 1984, Chief Loehr instituted a group of police and volunteers on horseback who could be called in to help search for missing persons in hilly or wooded terrain inaccessible to vehicles. "This is not a glory ride. This is not a plaything. If someone wants to join to be a cowboy, we're not interested," Loehr told the *Press Journal*. The mounted searchers got called out about twice a year.

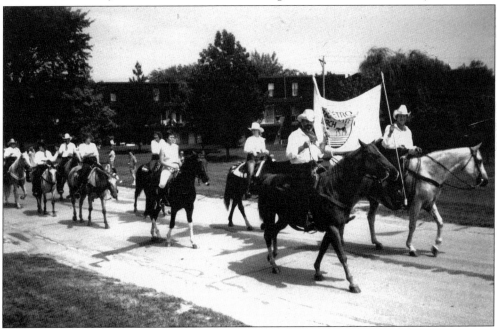

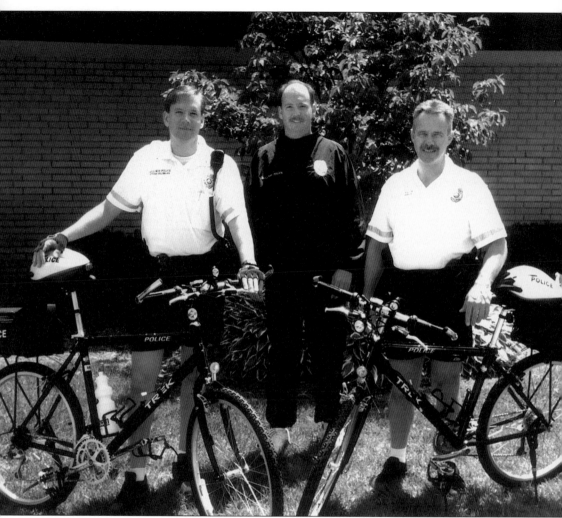

In 1996, the Ballwin Police Department added bike patrols to its law enforcement toolbox. Officers who have completed special training patrol the city on mountain bikes. Bicycle patrols offer quick access through traffic, parking lots, and to areas unreachable by car. Their nearly silent approach is often an advantage when investigating suspicious activity. The bicycle unit focuses special attention on subdivisions, apartment complexes, and commercial areas, as well as special events such as Ballwin Days and A Taste of Ballwin. Officers Jim Heldmann (left), Steve Morrison (center), and Ed Roberson (right) are part of this team.

In August 1981, the Ballwin, Ellisville, and Manchester Police Departments combined detectives into a special investigative group led by Lt. David Beckett. "It's without a doubt twice as effective . . . as opposed to the individual department setup," Beckett said. It allowed lawmen to work undercover in neighboring cities. Beckett served on the force from June 1963 until his retirement in February 1999. He died in November 2002.

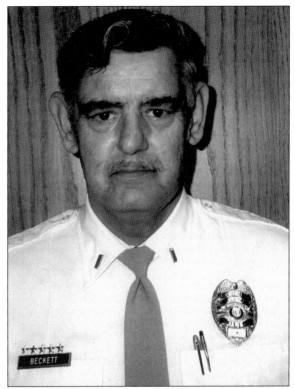

Prior to moving to the building at 14811 Manchester Road, city offices were housed in the Ballwin Municipal Building, at 300 City Hall Drive. The building was completed in 1970 at a cost of $150,000. Now known as the Donald "Red" Loehr Police and Court Center, it still serves as the main facility for the police department and as the site of board of aldermen meetings and the Ballwin Municipal Court.

A city the size of Ballwin, with a 2000 population of 28,000, requires a good many employees to provide the public services citizens expect. The city has about 150 employees split between four departments. Operating budget for the city in 2004 was $13.5 million, with a capital budget of $5.7 million. Since 1996, the city's main administrative offices have been at 14811 Manchester Road in a facility formerly owned by Charter Communications. This is an ideal location for the

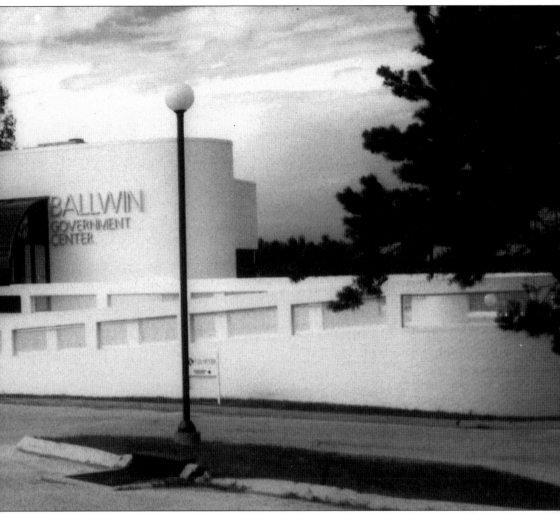

city because of its proximity to the former city hall, which still houses the police. Ballwin has a mayor, eight aldermen representing four wards, and a city administrator. Robert Kuntz has served as city administrator since 1988. That role was first established in 1979, when Bernard DiFlore was hired. Mike Herring took over in 1983 and served until Kuntz's arrival.

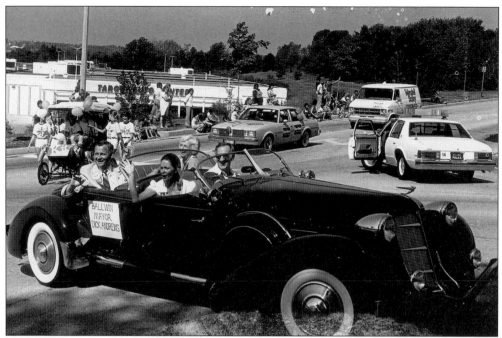

Since the last Ballwin history book was produced in 1979, the city has had four mayors. Dick Andrews was elected mayor in 1977 after serving as an alderman for 14 years. Here, he and his wife, Dottie, ride in the Ballwin Days parade in 1981. Former chief Red Loehr is driving the car. Andrews held office until 1995, serving nearly 20 years as mayor of Ballwin.

Edward Montgomery took over as mayor in 1995 after serving 24 years as alderman. Montgomery was in office until 1999, when Robert E. Jones was elected.

Robert E. Jones was elected as Ballwin's ninth mayor in 1999. Jones's father, Robert C. Jones, was Ballwin mayor from 1965 to 1971. Jones served six years, leaving office in 2005.

Former alderman Walter Young was elected as Ballwin's 10th mayor in April 2005. Young became interested in Ballwin politics during the annexation of his area into the city during the 1980s. In addition to his term on the board of aldermen, Young served on the planning and zoning commission and the board of adjustment, in total over 15 years in service to the city prior to becoming mayor.

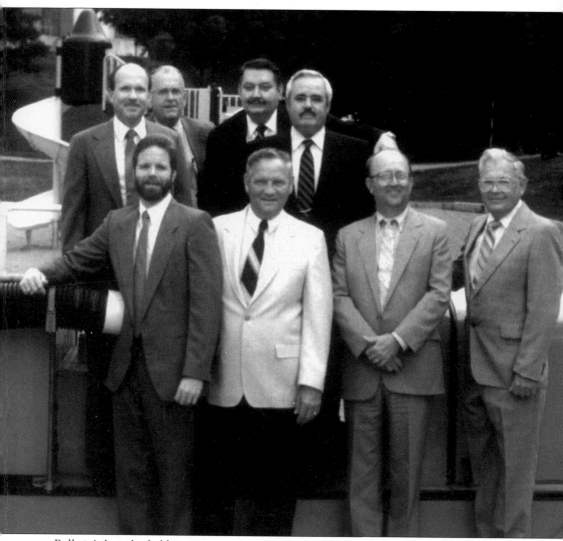

Ballwin's board of aldermen poses in 1990. From left to right are the following: (front row) Kent Martin, Mayor Dick Andrews, Jim Cummins, and Roy Anderson; (back row) Richard Velten, Edward Montgomery, Robert Pisarkiewicz, and Ron Nichols. Of his time as an alderman, Pisarkiewicz remembers, "Politics were different in those days. Everybody looked to you to come up with good ideas and then implement them. For instance, all we had was Vlasis Park and we knew we needed more recreational facilities. And so that's how we came up with the Pointe [at Ballwin Commons]. Of course, we didn't always see things the same way. You'd argue like hell at the meetings but then go have a beer together afterwards. Usually we worked pretty well together."

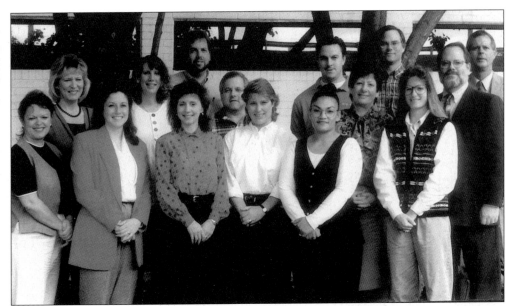

Employees in the administration department in 1997 are, from left to right, as follows: (front row) Joyce Wapelhorst, Haley Morrison, Marie Clark, Paula Reeds, Karen Anderson, and Lisa Evans; (back group, left side) Glenda Loehr, Kathy Medlin, Brad Holmes, and Gary Kramer; (back group, right side) Phil Smith, Kathy Tuttle, Bob Baxter, Tom Aiken, and city administrator Bob Kuntz.

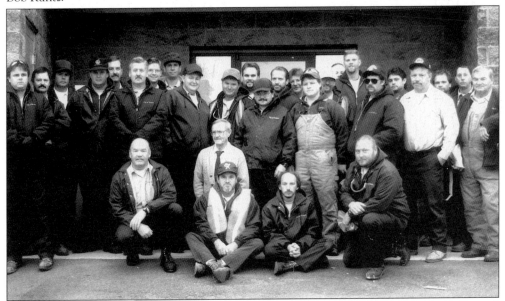

The public works department of 1997 poses here. From left to right are the following: (front row) Bernie Lajeuness, Russ Johnston (in tie), Dan Nix, Doug Steele, and Don Jessen; (back row, left group) Jeff Filley, Dennis Schwab, Eric Becker, Chuck Loyd, Art Levoy, Dan Schoenwalder, Jim Bottorff, Steve Ruby, and Dave McIntire; (back row, right group) Mike Callahan (in hat and reflective vest), Greg Mossman, John Lott, Pete Kraut, Kevin Beaman, Matt Thome, Mike Fink, Dave Bible (partially obscured), Leonard Clark, John Dippel, Landon Baumer, Dan Locuss, Dan Backues, Tim Clancy, and Jack Walkenhorst.

Ballwin's public works department is responsible for maintaining the city's roads and walkways. Capital improvement projects, such as street reconstruction and building new or replacement sections of sidewalk, are a significant portion of the work. In 2004, Ballwin spent over $2 million on capital improvements. Highly visible, too, is the department's maintenance program, including joint sealing and light surface repair. Most calls coming from residents are, perhaps not surprisingly, tied to pothole repair. In 2004, the public works crew fixed nearly 6,800 potholes around the city.

With commendable foresight, city organizers early on required land developers to contribute $25 per subdivision lot for parks and park development. One contractor, Fred Weber, also contributed labor and materials to build park roads and a sports field for the city. The city's first park was Vlasis Park, created in 1963. At 31 acres, it remains Ballwin's largest park.

The park was named for George Vlasis, mayor of Ballwin from 1956 to 1961. He is shown with Marian Gardner Hausman, Community Press publisher, at the Ballwin 10th anniversary celebration in 1960. Hausman and her family owned the Community Press from 1948 until 1975, when it was acquired by the Suburban Journals.

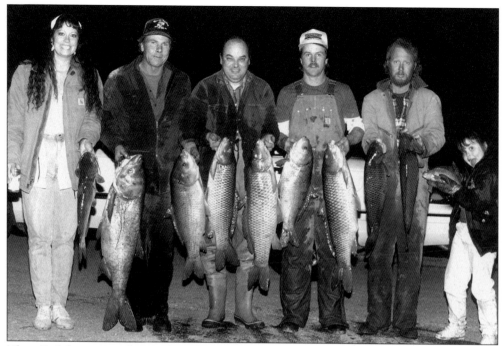

Vlasis Park has received a number of improvements over the years. When the city drained the pond in early 1993 to put in new fishing decks, walkways, lighting, and so on, these folks were the beneficiaries, netting some massive carp and catfish as the water fell.

The most dramatic facelift has come in the last five years. A new playground, funded by a $250,000 grant from the Municipal Park Grant Commission of St. Louis County, highlighted the improvements. The playground includes built-in water features for summertime fun, plus a 34-foot tower with a rubber safety surface under the entire play area. Additional enhancements included new parking lots, an events plaza, and new sidewalks and lighting.

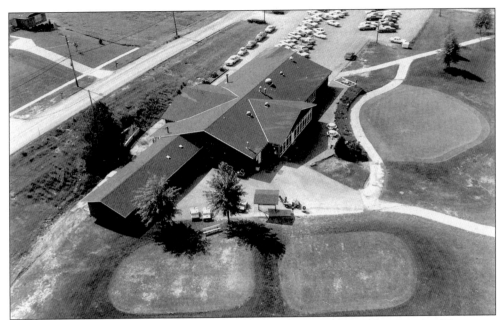

Thanks to the passage of a $1 million bond issue in 1973, the city was able to acquire 78 acres on Holloway Road from developer Herman Mayer. The land was the former Fox Creek Subdivision golf course. "Mayer had built Claymont subdivision," recalls former mayor Jon Bopp (1971–1977), "and wanted to divide up the ground and put 178 homes in there. That bond allowed us to buy the land for $750,000 and to put up the pool the next year for $250,000." And so Fox Creek Golf Course became the Ballwin Recreation Complex as well as the eventual site of the North Pointe aquatic complex. The clubhouse, shown above in the 1970s, continues to host numerous luncheons, business meetings, and social events. The bottom photograph shows a golfer on the course in the summer of 1987. Taken by Ken Westermann, this photograph was featured in the Ballwin city calendar in May 1988.

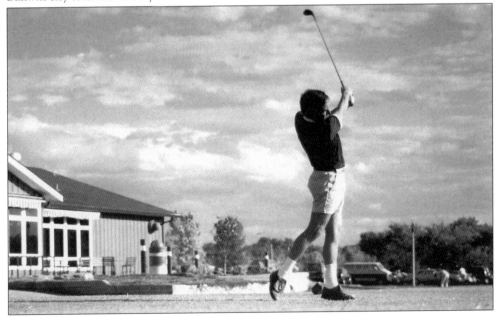

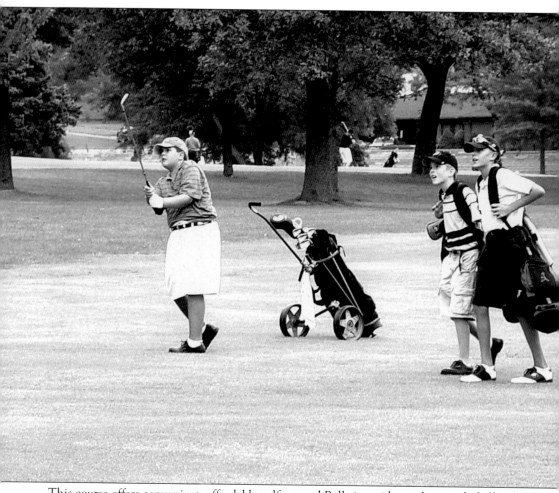

This course offers convenient, affordable golfing, and Ballwin residents along with duffers from neighboring communities know what a treasure lies in their backyard. From 1998 to 2003, on average, an astonishing 40,000 rounds of golf were played each year, fairly evenly split between Ballwin residents and nonresidents. A new generation of golfers is learning the game through the junior golf program, started in 2003 by the parks and recreation department. Saturday afternoon clinics were offered in March and April, and nearly 50 participants enrolled in a three-day summer clinic held in June. Nine-hole junior scrambles offered every other Thursday during the summer drew 40-plus golfers, on average, and the course brought the top junior golfers in the St. Louis area to Ballwin with the Gateway PGA Junior Tournament in July 2003 and the Junior Championship in August 2003.

To go with Vlasis Park, Ballwin has added several other parks over the years. New Ballwin Park opened in 1980, and in 1996 Ferris Park was added. Named for former alderman and city treasurer Bob Ferris, the nine-acre park features a unique pavilion that juts out into the woods. The Bonhomme Lions Club worked with city crews on its creation. At the dedication of the pavilion, Pat Ferris, widow of Bob Ferris, cuts the ribbons while their two sons, Billy and Bobby, look on. Parks director Linda Bruer is in the background. Esley Hamilton, an expert on historic preservation with St. Louis County, writes, "Ballwin has distinguished itself by acquiring some of these [properties] for public open space, notably Vlasis Park and the Fox Creek Golf Course."

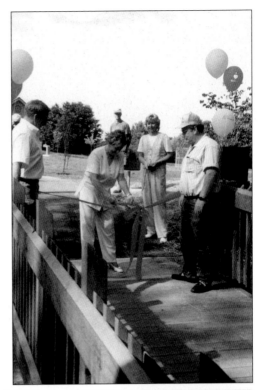

The state gave Ballwin the property on which Ferris Park was created. Development of the grounds cost $350,000 and resulted in a ballfield, playground, restrooms, and nature trails, plus the pavilion. The back side of the cedar deck sits among the trees about 15 feet above the forest floor. A "Branch Out Missouri" grant from the Missouri Department of Conservation has provided for the planting of 250 trees in the park.

Aldermen Jane Suozzi (left) and Terry Byatt were among those at the dedication, along with mascot of the parks and recreation department, unofficially known as Ballwin Bob.

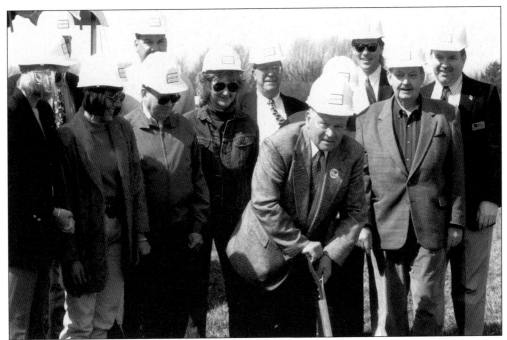

Around that same time, the city began work on a substantial new development, a facility that would be called the Pointe at Ballwin Commons. City officials celebrated the groundbreaking at the site off Old Ballwin Road in March 1995. Mayor Dick Andrews turns the shovel. Behind him are, from left to right, Linda Bruer, director of parks and recreation; architect Reed Voorhees (partially obscured); Stacy Noubarian, chairman of the citizen's committee; Tom Moorkamp, Ballwin special projects coordinator; alderman Richard Velten (with sunglasses); alderman Kay Easter; Walter Kisling, Multi-plex Corporation; Bob Schafer, Schafer Construction; alderman Bob Pisarkiewicz, and alderman Walter Young. Construction started shortly thereafter on the 12.8-acre site and continued through the rest of 1995. The Pointe at Ballwin Commons opened in July 1996.

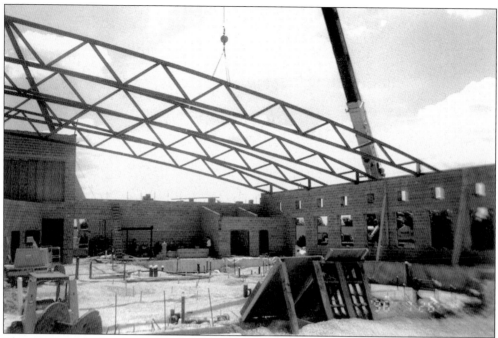

The 2,200-square-foot leisure pool, a favorite component for all ages, was added in a second phase due to citizen interest and as an additional source of revenue. Construction on Phase II began in February 1996 after passage of a half-cent capital improvements sales tax in November 1995. Total cost for the leisure pool phase was $3.12 million.

Naturally, the facility has been popular with residents, but especially so for kids and families. Though there is snow on the ground, these youngsters are getting ready to go in and hit the pool. In 2003, the facility had over 250,000 visits, about half of whom were Ballwin residents. This number does not include those who attended meetings at the Pointe, or visited the game room or lobby area.

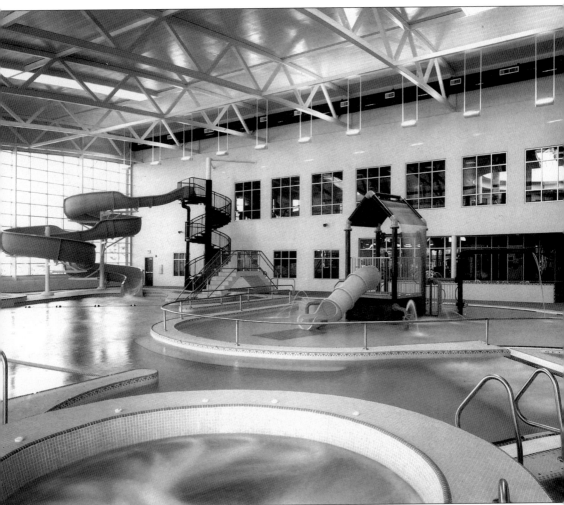

The Pointe at Ballwin Commons was a much needed recreation facility for Ballwin residents. Featuring two full gymnasiums, an indoor track, a full-circuit weight system, treadmills, exercise bikes, and step machines, the facility also offers a dance/aerobic studio and meeting rooms for up to 150 people. The indoor leisure pool, shown above, has a water playground, three lap lanes, a lazy river, a two-story water slide, a spa, and other features.

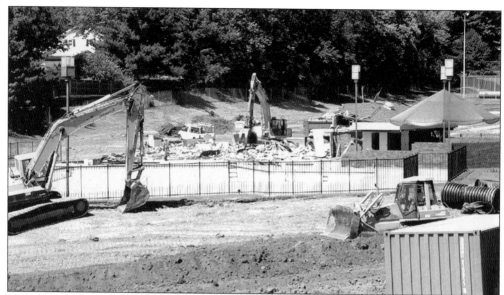

Built in 1974, the outdoor Ballwin pool (335 Holloway Road) that preceded the Pointe at Ballwin Commons was approaching 30 years of use. The city recognized that the pool was deteriorating quickly and suggested a new state-of-the-art complex, an outdoor complement to the top-notch Pointe. Residents approved a half-cent sales tax increase in April 2001 to fund the $7.5 million project, called the North Pointe Aquatic Center.

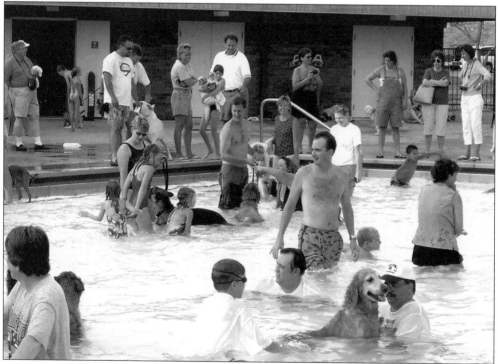

When some folks said the old pool had "gone to the dogs," they may have been talking about this popular event in the 1990s. Canine owners were allowed to bring their pooches for a dip on several designated occasions when the pool was not open for regular swim sessions.

From the front page of the *Press Journal* of June 11, 2003, this photograph shows a worker in the pool working on the water playground at the North Pointe Aquatic Center. After the close of the 2002 summer swimming season, crews demolished the old pool and began construction on the new one, working through the winter to have it done on time for opening day, June 14, 2003. "We've targeted different water amusement areas in the complex for residents of various ages," Susie Boone, Ballwin recreation superintendent, told the *Press Journal* the week the complex opened. Some minor tasks remained to be completed, she said, but those finishing touches were all "out of the public eye." Boone added, "We're just hoping the water won't be chilly that first day."

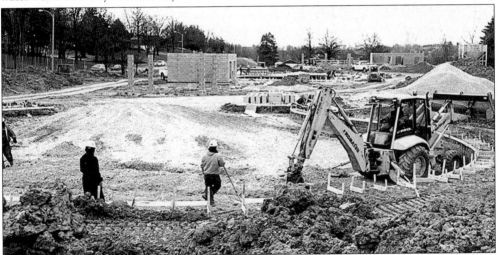

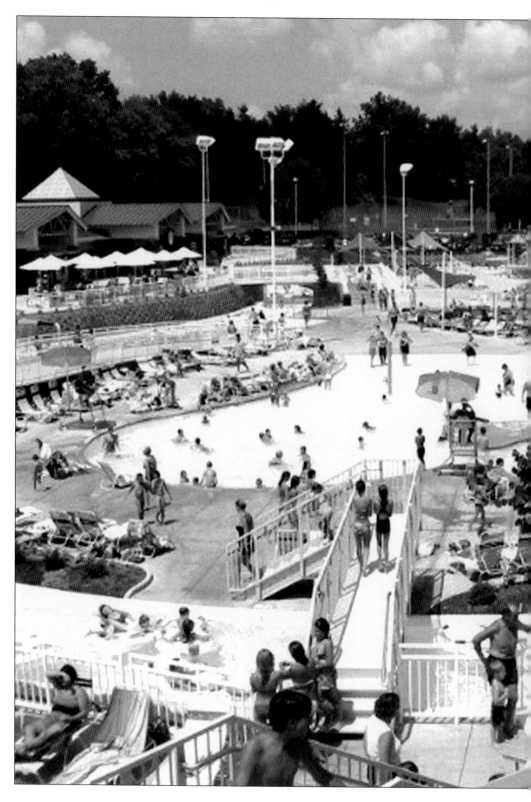

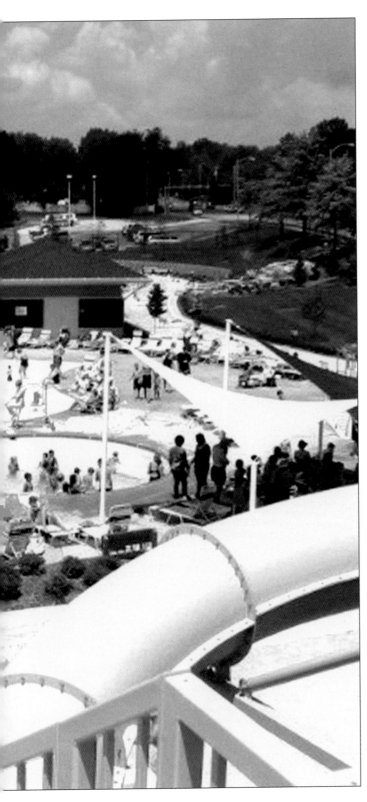

The outdoor pool is open from Memorial Day through Labor Day. In addition to a 10-lane competition pool with rope swing and two diving boards, North Pointe features a lazy river, two two-story water slides, and an extensive play area. This photograph shows a view of the complex from the slide tower. Average attendance in the first year was just over 1,000 visitors a day, totaling 83,000 for 2003, split about equally between Ballwin residents and nonresidents. It was named best public pool by *St. Louis Design* magazine and received an award for best design and construction by the National Pool and Spa Institute. Despite the new features, some still missed the old pool. Superintendent of recreation Susie Boone said, "I told them I knew they had great memories. And I said it will be up to us to make great new memories."

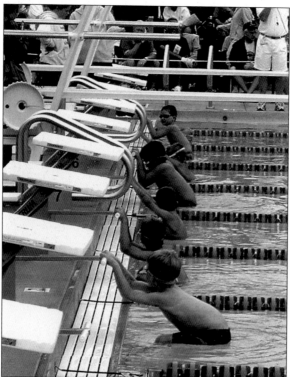

With its 10-lane competition pool, North Pointe is a great complex for competitive swimming. It is home to the Ballwin swim and dive teams and hosts a number of meets during the summer. In this photograph, six-and-under boys line up for the finals of the 25-meter backstroke at the Suburban Swim Conference meet in 2004.

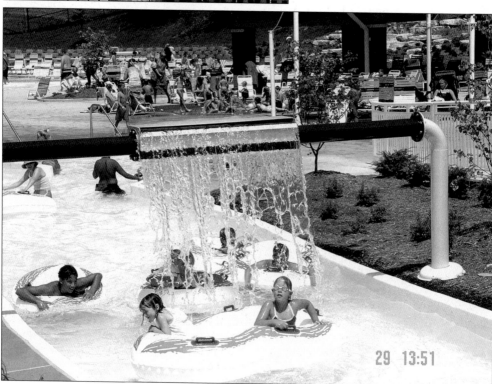

29 13:51

Here we see people enjoying the lazy river on a hot summer day.

The parks and recreation department offers a number of classes. One especially popular event, started in 1994, is the father-daughter Valentine's Day dance. Here, dads and daughters do the "YMCA" dance in February 2001. The golf course clubhouse serves as the site for the event. "This year [2005] we added a mother and son dance," says Linda Bruer, parks and recreation director.

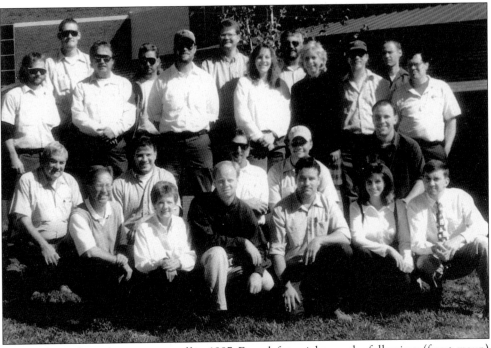

Here is the parks and recreation staff in 1997. From left to right are the following: (front group) Jack Walkenhorst, David Furlong, Tim Stearns, Sara Jane Davis, John Hoffman, Mike Rodgers, Eric Okler (in hat), Dave Lorenz, Laurie Yancey, Mike Nordmann, and Tom McCarthy; (back row) Jeff Merseal, Mike Stinger, Bob Beuchert, Darryl Best, Dan Trower, Steve Gayfield, Missy Morarity, Mike Buttry, director Linda Bruer, Mark Nienaber, and Dwayne Bennett.

FALL ARTS PREVIEW
FRIDAY, NOV. 19 (7PM - 9PM)
THE POINTE AT BALLWIN COMMONS

The Ballwin Arts Commission will be hosting a wine & cheese reception to preview the exciting work of the Greater St. Louis Art Association. Artists will have their work for sale at the Pointe 10am - 5pm and Sun Nov. 21 Weekend admission is free. Artists will have their work for Sat. Nov. 20 from from 11am - 5pm.

Come Friday evening for an early peek at their work. You will be able to purchase the artists' pieces and bid on silent auction of pieces donated by Association members.

Proceeds will benefit the Ballwin Arts Commission raising funds for sculpture in Vlasis Park. The cost is $25, payable at the door. Call
636-227-8950 to register.

Co-sponsored by UMB Bank

The Ballwin Visual and Performing Arts Commission was first established in 1999, though the roots of Ballwin's involvement in the arts go back to the 1970s. The parks board, which was established in 1971, held an arts and crafts show in September 1973, a joint event with the West County Artists Association. Shown here is a flyer from a November 2004 event held in conjunction with the Greater St. Louis Art Association.

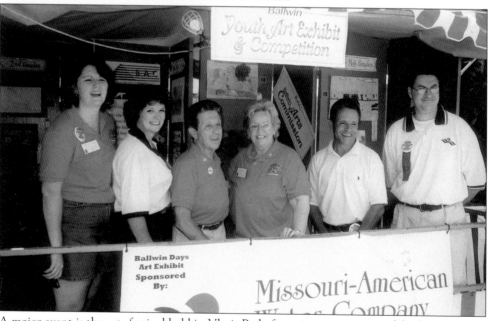

A major event is the arts festival held in Vlasis Park, featuring art, music, and food. Art for sale is exhibited by area artists, and children can take part in art activities. The members of the 2002 organizing committee are, from left to right, Christi Brothers, Ginny Altrogge, Bud Brown, June Brown, Brad Brown, and a representative from the sponsor, the Missouri-American Water Company. (Photograph courtesy June Brown.)

Mae Peterson, born in 1917, began writing poetry during World War II. A job-related accident at the Weldon Spring Ordnance Works rendered her inactive for a year and a half. She had inhaled some fumes, and the doctor directed that she sit in the backyard in the sun all day, every day. "The doctor said I was supposed to be out there naked, but I wasn't about to do that," she recalls. "Daddy certainly didn't approve of it either." To fill those long hours, Mae picked up a children's book from a garage sale and was inspired to put pen to paper. Examples of her poetry were used in the 1993 Ballwin calendar. Here is one used for April: "I saw the leaves dance today / First they curtsey, then they sway. / All day they frolic to and fro, / Winking and flirting as they go. / Twirling and dipping gracefully, / I wish a dance they would ask of me." (Photograph courtesy Mae Peterson.)

Mille Wallace, another Ballwin poet, produced three books of her work. "Something makes me happy or sad—inspires me—and I sit down. It comes as fast as I write it down." Wallace's family lived in Ballwin since her great-grandparents, the Buermanns, immigrated in the 1800s. She attended Ballwin Elementary School, and her work touches on growing up in Ballwin when it was a much smaller town. "We used to play hopscotch on Ries Road (which is now indeed a very busy road) after school and on Saturdays," recalls Wallace in the preface of her first book. Wallace (née Hunnicutt) eloped in 1946 at age 17 with a 21-year-old former Marine, Clyde Wallace. She had just graduated from Eureka High School. "I don't know why," said Wallace, "it just seemed like an exciting thing to do at 17." Their marriage lasted 56 years and produced three children and six grandchildren. She died in 2002. (Photograph courtesy Pam Wallace.)

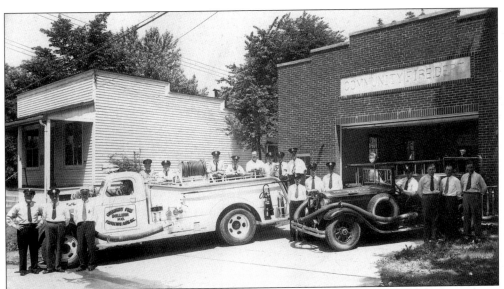

Fire protection for the Ballwin community comes from the Metro West Fire Protection District, which has roots going back to 1934. Originally organized as a volunteer department and funded through the sale of fire tags that residents purchased and nailed to their houses, the Community Fire Association operated from 1934 to 1957. In 1957, citizens voted for a tax to create the Ballwin Fire Protection District. A new firehouse was built and the first paid staff hired in 1960. This photograph shows Engine House No. 1, built in 1946 and used until 1960. Ted Dahlke, third from the left, is the fire chief. This photograph was taken at the dedication of the truck behind him, which the department had purchased for $5,000 in 1947. The truck at the right that it replaced was built from the body of a 1909 Cadillac truck mounted on an old Nash chassis, coupled with a souped-up engine that would let it roar along comfortably at 100 miles per hour.

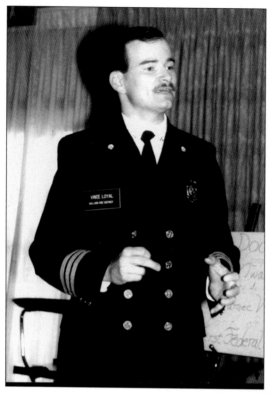

Chief Vincent Loyal (left) already had 25 years of service with the Metro West Fire Protection District when he was named chief in 2003. He replaced longtime chief Jim Silvernail (below), who retired that year after 33 years with the district, including 23 years as chief. Silvernail started as a volunteer with the district as a 16-year-old in 1959. "I've always taken care of the firefighters and the budget," Silvernail said. "I've always been honest with the men. During my 23 years as chief, I kept everybody safe. I always brought everyone home that I took out." Ballwin fire chiefs over the years include the following: (as a volunteer force, 1933–1960) Charlie Buermann, Walter Busch, Ted Dahlke, Richard Rethmeier, Herman Baumer, Roy Hellman, and Charlie Burkhardt; (as a paid force, 1960–present) Frank Rucker (1960–1980), James Silvernail (1980–2003), and Vince Loyal (2003–present).

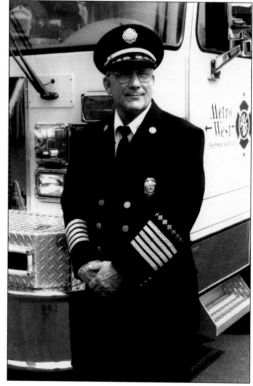

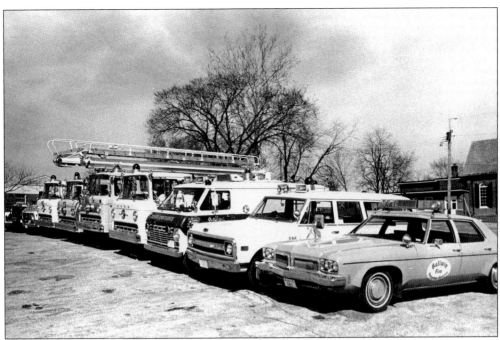

First known as the Ballwin Fire Department, it was renamed the Metro West Fire Protection District in April 1993. The 57.5-square-mile area that the district serves includes all or portions of Ballwin, Chesterfield, Clarkson Valley, Castlewood, Ellisville, Sherman, Wildwood, Winchester, and unincorporated St. Louis County. The district has five ambulances, over a dozen different fire trucks, and various pieces of specialty equipment, including a rescue boat. District personnel respond to nearly 6,000 calls per year. The photographs above show some of the department's equipment from the 1970s, as well as the new Station No. 1, located at 14835 Manchester Road in Ballwin. Finished in 1996, it replaced the old Station No. 1, still sitting to the right of it in this picture. That structure, which became operational in 1960, has since been torn down. (Photographs courtesy Metro West Fire Protection District.)

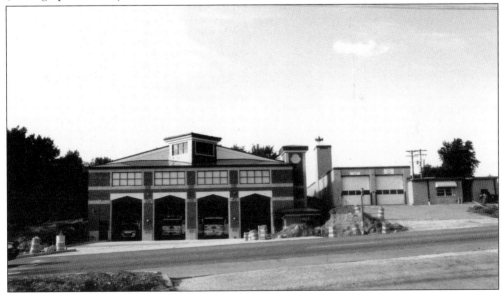

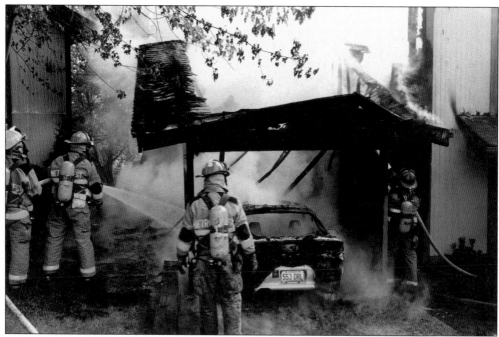

In addition to fighting fires, the men and women of the Metro West Fire Protection District are active in the community in a number of ways. In addition to providing education through CPR programs, classroom visits, and tours of the firehouse, firefighters are a regular presence at community events. (Photograph courtesy Metro West Fire Protection District.)

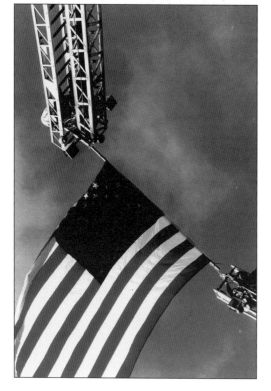

Two firefighters work to raise Old Glory high in the air between the ladders of two fire trucks at Ballwin Days 1998.

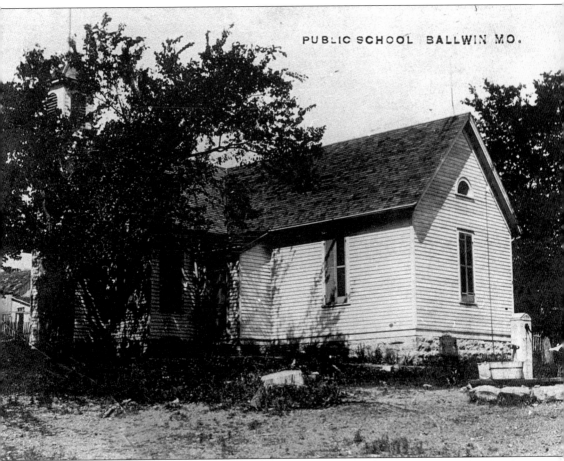

PUBLIC SCHOOL BALLWIN MO.

Formal schooling in Ballwin goes back to 1855, when the German settlers established a school as an offshoot of the Methodist Episcopal church. After a local board of education was formed to create a public school, this property was purchased from the Methodists for $800 in 1869. The congregation decided to build a new church, which still stands today on a high point of Manchester Road as Salem Methodist Church. In 1900, this one-room schoolhouse was replaced by a new two-room structure, built for a total of $1,500. The start of school was delayed until November that year when the building was finally ready. This schoolhouse is shown in the photograph above. Note the pump to the right used for drawing drinking water from a cistern. "Either a teacher or upper classman filled a bucket at the pump and we used a ladle to fill our individual cups," recalled Donald Essen, a graduate of the school. "Our toilet was a divided outhouse. One side for boys and the other for the girls."

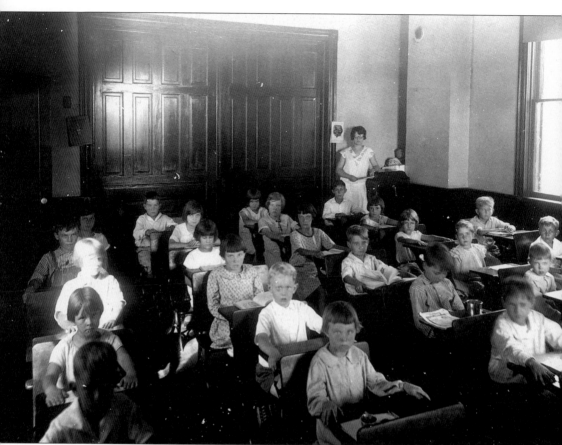

The two-room schoolhouse meant children were split into upper-grade and lower-grade classrooms. This photograph, taken c. 1928, shows Mamie Rathert's lower-grade class. Pictured from front to back in each row, starting from the left, are the following: (first row) Donald Essen, Charlotte Feldmann, Lorraine Loesch, Roy Rockwell, and Carrie Lee Bopp; (second row) Mae Rockwell, Herman Baumer, Marie Rockwell, Ruth Schrader, Hilda Prockel, and Clarence Reinecke; (third row) Nelson Prockel, Herbert Rockwell, Fred Loesch, Lavern Walka, Hilda Houssels, and Elsie Prockel; (fourth row) Vernon Trog, Violet Koebel, Isabelle Arft, Doris Potthast, and Daniel Woerther. The two boys in the last row on the right are Billy Rethmeier and Clifford Kraus. Mamie Rathert eventually married Oliver Blinne. Supporting the local school was a community endeavor, and in April 1928, a Ballwin Parent-Teacher Association was formed to help provide needed items for the classroom. Members paid dues of 25¢ per month, and these funds (plus proceeds from ice-cream socials, bake sales, and so on) helped purchase furnishings such as waste baskets, window shades, blackboard erasers, and even a big dictionary and the stand on which it rested.

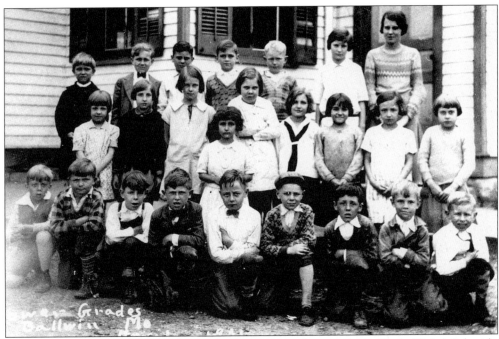

In the 1930–1931 school year, these students were in a class taught by Ruth (Ficke) Schmidt. From left to right are the following: (front row) William Hale, Bill Kraus, Vernon Trog, Howard Sanders, Herb Koebel, Matt Richard Jr., Marvin Potthast, Calvin Potthast, and Melvin Dahlke; (middle row) Lotus Higgins, Violet Koebel, Charlotte Feldmann, Anna Pappas (standing slightly forward), Flora Ruby, Isabelle Arft, Faye Tait, Helen Pappas, and Dorothy Fischbeck; (back row) Virgil Wiebe, Bill Rethmeier, Richard Tompkins, Don Essen, Herman Baumer, Gertrude Rose, and Ruth Schmidt. The Ballwin PTA not only bought items for the classroom, but they also made sure the kids had special treats. In May 1929, the sum of $3.80 went to grocer Roy Kraus for ice cream at an end-of-the-year event. The photograph below shows the kids on their way to a field trip at the Forest Park Highlands.

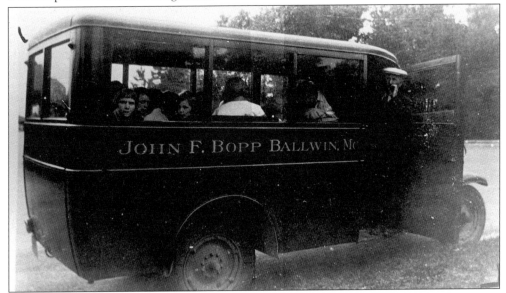

The two-room wooden structure served until 1938, when this three-room brick schoolhouse was built at a cost of $22,500. The new building had a capacity of 40 students in each class and featured such conveniences as individual desks and chairs and "modern lavatories." This original section still serves as a portion of the Ballwin Elementary School today, though it has been modified and expanded upon many times since then. While Ballwin School stood independent for nearly 80 years, the times, as they say, were a-changin'. Beginning in 1949, new Missouri law encouraged the reorganization and consolidation of school districts across the state. Ballwin School became a part of the R-6 School District in 1950, which we now know as the Rockwood School District. Not long after that, in May 1954, voters approved creation of the Parkway School District, formed from the Fern Ridge, Weber, and Mason Ridge (itself comprised of the erstwhile Manchester and Barretts schools) districts. This allowed the creation of Parkway Junior-Senior High School and eventually produced a number of schools that also serve Ballwin residents.

With the rapid growth of the Ballwin area in the 1950s and 1960s, other schools were soon necessary to serve the increasing numbers of children who accompanied these young families moving in. In rapid succession, five schools opened, including a new seven-room Westridge Elementary in 1956. A nine-room Woerther Elementary opened in 1965; by 1969, it had a total of 28 rooms and looked as it appears above.

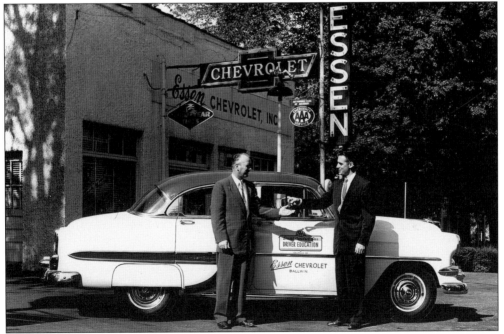

In 1954, Essen Chevrolet sold this Bel-Air to Rockwood School District for use in the driver education program at Eureka High School. Taking the keys from Don Essen is Morgan Selvidge, Rockwood District superintendent from 1949 to 1970. (Photograph courtesy Don Essen.)

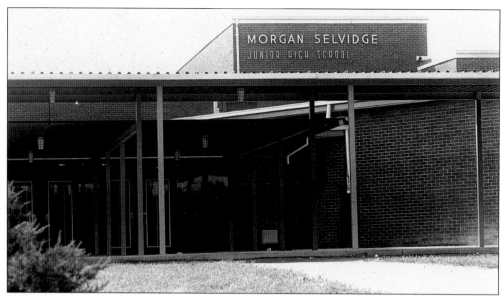

For middle school, students may attend Crestview or Selvidge, or Parkway West Junior High or Parkway Southwest Middle School. Prior to Lafayette High School opening in 1960, Ballwin teens once had to travel to Eureka, Maplewood, Webster Groves, or other schools for upper-level education. Rather than see it as a burden, Mille Wallace enjoyed the journey. "Going to high school was fun. We had to ride the bus to and from a town called Eureka," recalled Wallace.

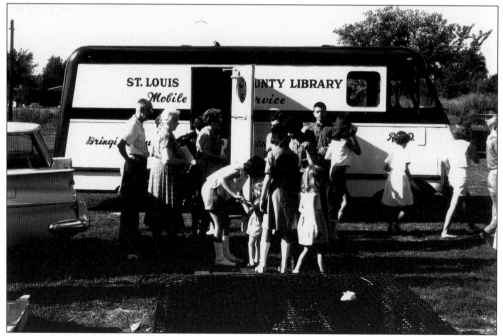

Beginning in 1947, the St. Louis County Library used a converted Winnebago to provide Bookmobile service to the community. In addition to regular neighborhood stops and visits to retirement centers, the Bookmobile made the rounds of Ballwin-area schools. This augmented the schools' own libraries and allowed kids to borrow library books that they might not otherwise have had easy access to.

Ralph Blevins and an unidentified Woerther student are pictured here on Earth Day 1990. Blevins began his career as a sixth-grade teacher at Woerther in 1968 and then taught at several other Rockwood schools before returning to Woerther to become principal in 1982. Blevins died of a heart attack during spring break in April 1995. Blevins Elementary School, opened in 1999, was named in his honor. A Rockwood tribute to Blevins says that his influence as a teacher, administrator, and coach "taught that fairness and patience are important and should be coupled with an effort to do one's best in all of life's pursuits. He always brought out the finest in students, teachers and staff at his school and also expected the best of himself." (Photograph courtesy Woerther Elementary.)

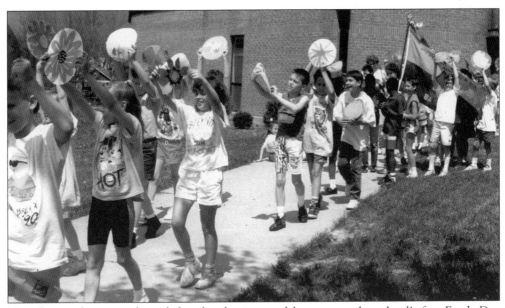

Woerther students parade with handmade signs and banners at the school's first Earth Day celebration in 1990. (Photograph courtesy Woerther Elementary.)

Woerther Elementary, like the other facilities in the Rockwood and Parkway School Districts, continues to enjoy renovations and expansions to update older facilities and to allow schools to take advantage of the most current educational technologies. Two Woerther students are seen here at the opening of the renovated Margaret Sutton library facility in the fall of 2004. The improvements brought more space, more books, better lighting, and use of a smart board and other high-tech features. Thirty-four teachers plus a number of additional support and administrative staff are responsible for the education of the school's 600-plus students in kindergarten through grade five. More than half of these educators have advanced degrees, and the average tenure for teachers at Woerther approaches 14 years in the classroom. (Photograph courtesy Woerther Elementary.)

Westridge Elementary, which opened in 1956, was one of five schools that opened in rapid succession to keep up with Ballwin's burgeoning population. Starting with five rooms, it has had several additions built to keep pace with growing enrollment. Westridge teacher Tina Zuroweste is pictured with a group of third-grade students.

This photograph shows the January 1990 groundbreaking. Younger Ballwin children also attend some Parkway elementary schools, including Henry, Claymont, and Oak Brook Schools. Oak Brook Elementary, the newest area school, was built in 1990. It opened on January 22, 1991, as Parkway's 18th elementary school.

A unique aspect of Oak Brook Elementary is the degree to which community involvement factored into its physical design and construction, especially with regards to its outside play areas. In February 1991, the Parkway School District brought in Robert Leathers, an architect from Ithaca, New York, with 500 playgrounds to his credit. Leathers met with the 575 kids at the school, drafting them as consultants on playground design. Though Leathers tactfully nixed suggestions for bumper cars and a roller coaster, he did say yes to a castle haunted with mummies, a coffin, monsters, and a spider web. The result, Castlezania, was built over five days in October 1991 by children, parents, grandparents, and district employees. "We're not just building a playground, we're having an event—a community project," said Mike Cosgrove, physical education instructor at Oak. (Marilyn Brown photographs courtesy Oak Brook Elementary.)

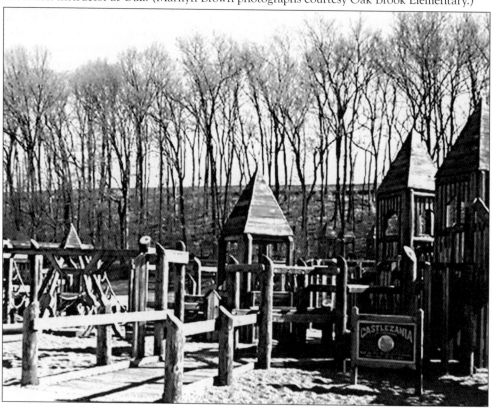

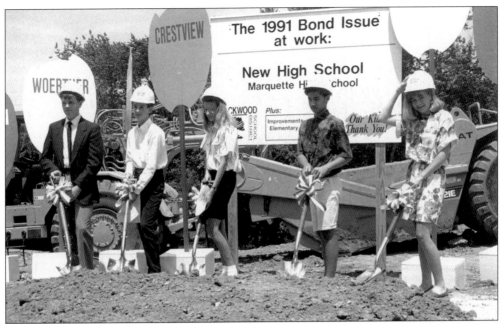

Since the opening of Marquette High School in August 1993, senior-level Ballwin students primarily attend either there or at Parkway West or South high schools. Marquette was built to support the fast-growing population on the west edge of Ballwin. In addition to Ballwin students, Marquette educates kids from Clarkson Valley, Chesterfield, Grover, and Ellisville. One of the nice things about building a relatively new school is that technology is up to date and incorporated in its design. The entire Marquette facility is wired for computer and video networking. Faculty use the computer network for such things as keeping attendance records, using the Internet, and sending e-mail. The curriculum of Marquette offers courses at all levels of learning, including an active college preparatory program. Nearly 90 percent of the graduating seniors attend a two- or four-year college. (Photograph courtesy Rockwood School District.)

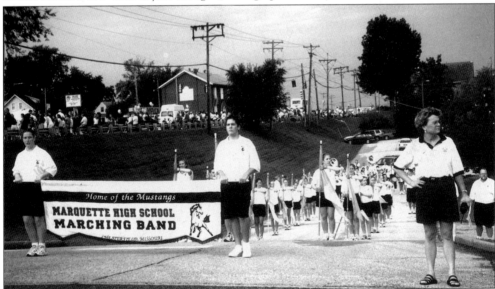

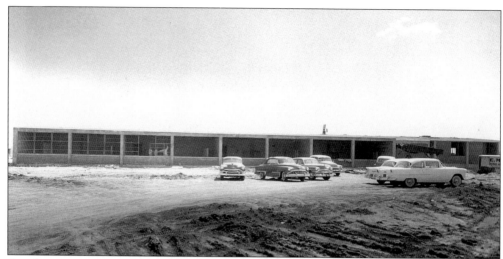

Another option for quality education can be found at the elementary school operated by the Church of the Holy Infant, which started in Ballwin in 1954. The top photograph shows the school under construction in April 1956, and the bottom photograph shows a completed school and church situated on New Ballwin Road. Note the newly constructed houses behind the complex. It was the rapid addition of a number of subdivisions like these that helped swell Ballwin's population. Beginning in 1951, with the construction of the Ballwin Meadows and Lock subdivisions, nearly 20 developments would be built over the next 10 years. "Behind the commercial development which forms the public face of Ballwin, the original old community is almost entirely surrounded by post-war residential subdivisions," writes Esley Hamilton. (Photographs courtesy Holy Infant.)

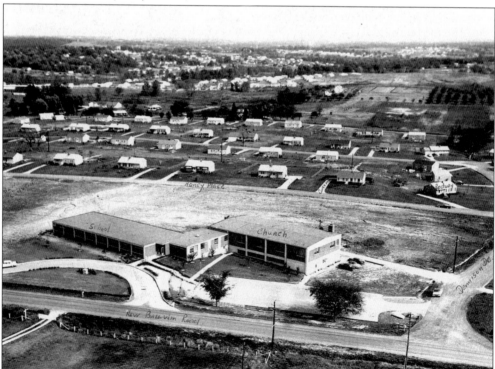

Five

FAMILY AND
COMMUNITY LIFE

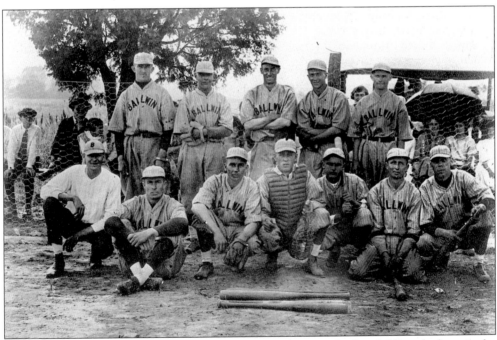

Baseball and Ballwin have gone together for nearly 100 years. The first field was laid out in the 1920s behind Schrader Funeral Home, and various locations have been used over the decades for ball games. Just about any place with enough space to launch a deep fly ball has hosted games. This team represented Ballwin in 1922. From left to right are the following: (front row) manager Fred Rethmeier, Melvin "Hootie" Grothpeter, Leonard Haas, Emil Niere, Bill McKinnon, Oliver "Bee" Grothpeter, and Ted Schrader; (back row) Ted Dahlke, Arthur Bueker, Ted Kopp, Irwin Peterson, and Charles Dickerson.

ORGANIZED UNDER THE LAWS OF THE STATE OF MISSOURI

BALLWIN ATHLETIC ASSOCIATION

BALLWIN, MISSOURI

THIS CERTIFIES THAT *Dr. B. R. and Annette Loving* is the owner of
Ten *Shares of the Capital Stock of*

BALLWIN ATHLETIC ASSOCIATION

transferable only on the books of the Corporation by the holder hereof in person or by Attorney upon surrender of this Certificate properly endorsed

In Witness Whereof, the said Corporation has caused this Certificate to be signed by its duly authorized officers and to be sealed with the seal of the Corporation this 10th day of May A.D. 1946.

Louis H. Trog
SECRETARY

Fred Rethmeier
PRESIDENT

1 Shares $20.00 Each.

BALLWIN ATHLETIC ASSOCIATION

Lifetime Voting Members Ballwin, Missouri:

Andereck, Harry
Arft, E.C.
Arft, George A.
Arft, George R.
Arft, Henry
Arnold, George
Bach, Bert
Blase, Fred
Blinne, Oliver
Bopp, Larry
Bopp, Raymond
Bopp, Richard
Bunch, Walter
Carey, Art
Carey, Dave
Dahlke, Mel
Davis, Bud
Dickinson, Russ
Eschenbrenner, Harry
Froesel, Leroy
Fudge, Beryl
Fudge, Robert
Haenni, Lee
Harman, Clark
Hellmann, Dale
Hoffmann, Leo
Holloway, Verne
Hunnicutt, T. J.
Kelly, Benton
Kloppenburg, Charles
Koch, Henry
Koebel, E.A.
Koebel, Roy
Kokesh, Ed
Kraus, Clifford
Kraus, Roy
Kraus, R. W.
Loehr, Ed
Loving, Rush
Marcus, Is
McCrew, Dave

McKinley, James
McKinnon, W. A.
Mueller, Herb
Mueller, Lee
Mueller, Walter
Mulvaney, Herb
Peterson, Walter
Probst, Walter
Pujol, Elmray
Pujol, Roy
Rasch, Henry
Rasch, Robert
Rauscher, C. W.
Rethmeier, Fred
Rethmeier, Norman Sr.,
Rethmeier, Richard
Rethmeier, Robert
Rethmeier, Theo
Roellig, Dan
Sappington, Bill
Schrader, Harold
Schrader, Harry
Slettery, John
Sodoma, Mike
Strieff, John
Thurmond, George
Trog, Louis
Vlasis, George
Walka, Chris
Wehrle, Frank
Woerther, Henry F.
Wussow, Roland

ROACH, WALTER

Ballwin Athletic Association was formally established on March 12, 1940. In May 1946, the group sold shares of stock to purchase and develop 10 acres of land next to Ballwin Elementary. The land, purchased from Charles Heim, cost $500 an acre. This certificate was the first one sold and was for 10 shares of stock at $20 each to Dr. Benjamin Rush Loving and his wife, Annette. Louis Trog, secretary, and Fred Rethmeier, president, signed the certificate. The athletic association sold new shares of stock in 1950 to fund the purchase of lights, which provided the first illuminated field in St. Louis County. Bleachers and refreshment stands followed as well. Those charter members involved in the formal creation and incorporation of Ballwin Athletic Association were granted lifetime membership and voting privileges in the organization. (Document provided by Jim Eschenbrenner.)

In 1983, the Ballwin Athletic Association hosted Team USA and Team Korea for the USA-Korea collegiate baseball all-star championship series. Opening day was June 12. Ballwin resident Jim Eschenbrenner took a number of photographs, some capturing a young ballplayer named Mark McGwire. "Of course, we didn't really know then who he was or just how famous he would become," Eschenbrenner said of McGwire. McGwire, even then towering over his teammates, stands second from the right, with body partially turned, in the upper photograph. In the bottom photograph, he stands with back to camera, stretching to take a throw from a teammate. Jim Eschenbrenner is the son of Ballwin resident Harry "Hap" Eschenbrenner, also a tremendous baseball player in his own right. Hap Eschenbrenner was a charter inductee of the Greater St. Louis Amateur Baseball Hall of Fame in 1974. (Photographs courtesy Jim Eschenbrenner.)

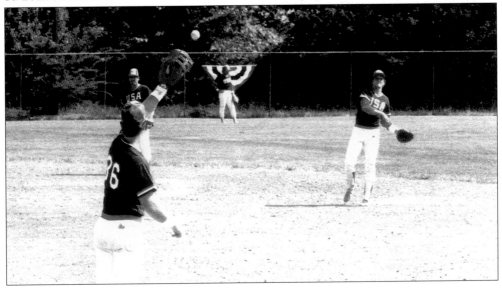

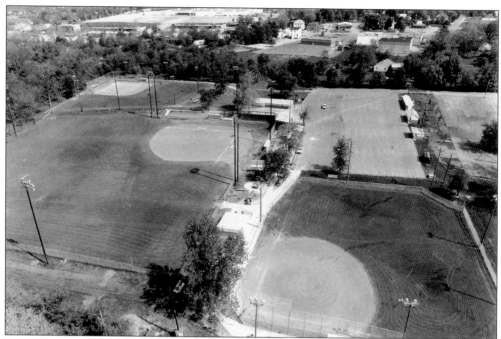

The Ballwin Athletic Complex is shown above in the 1970s. Thousands of kids have played baseball on these fields over the years, including the youngster below. The photograph was taken in 1990 by Nancy Longhibler and was used in the Ballwin calendar for April 1991. Who knows? She may have been taking a picture of the next home run king without even realizing it. Some stats include the following: 2,648 total participants in teams based at Ballwin Athletic Association in 2004; 2,150 total games played at BAA in 2004, including tournaments; and 4,300 umpires needed over the course of the year. As many as 22 umpires will work any given weeknight; that number soars up to 80 umpires calling balls and strikes on a weekend day.

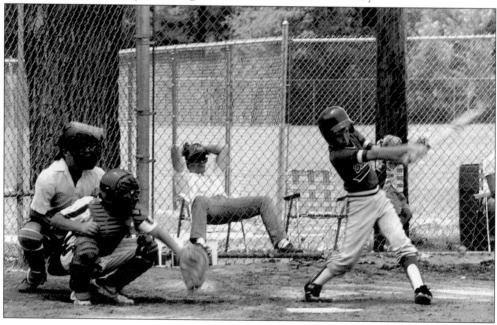

Several notable players have come out of Ballwin, including former police chief Red Loehr, who played with the Cardinals minor-league organization in the 1940s and 1950s. Big-leaguer Hank Arft played with the St. Louis Browns from 1948 to 1952. The lefty first baseman hit .375 in 1950, and longtime *St. Louis Post-Dispatch* columnist Amadee Wohlschlager drew the image to the right in conjunction with an event honoring Arft around that time. In the St. Louis Browns team photograph, Arft sits second from left in the first row. When these big-league teams considered equipment and uniforms to be no longer serviceable, Arft and Loehr would take them to the boys back home. This resulted in what looked like a mishmash of jerseys, but you can believe that the boys were thrilled to have the equipment. (Photographs courtesy Ruth Schrader Arft.)

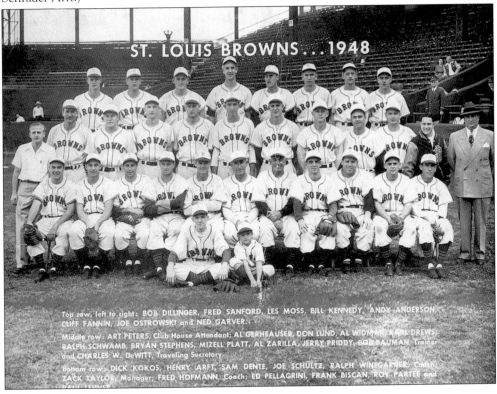

ST. LOUIS BROWNS...1948

Top row, left to right: BOB DILLINGER, FRED SANFORD, LES MOSS, BILL KENNEDY, ANDY ANDERSON, CLIFF FANNIN, JOE OSTROWSKI and NED GARVER.

Middle row: ART PETERS, Club House Attendant; AL GERHEAUSER, DON LUND, AL WIDMAR, KARL DREWS, RALPH SCHWAMB, BRYAN STEPHENS, MIZELL PLATT, AL ZARILLA, JERRY PRIDDY, BOB BAUMAN, Trainer and CHARLES W. DeWITT, Traveling Secretary.

Bottom row: DICK KOKOS, HENRY ARFT, SAM DENTE, JOE SCHULTZ, RALPH WINEGARNER, Coach; ZACK TAYLOR, Manager; FRED HOFMANN, Coach; ED PELLAGRINI, FRANK BISCAN, ROY PARTEE and PAUL LEHNER.

Ballwin Athletic Association created a wall of honor in 2003. It recognizes those individuals and organizations that have made significant contributions to the association over many years. The photograph above shows the inaugural group. The contributors included Richard Bopp, Clifford Kraus, Louis H. Trog, George Arft Jr., Fred Rethmeier, Bill Fredrichs, Jerry Rogers, Gene Lanham, Bill Laughlin, Olen Golden, Donald "Red" Loehr, Bob Bonzon, Ed Montgomery, Harry "Hap" Eschenbrenner, Tom Sickinger, Bruce Frankenfield, Bob Mertz, David Price, Tony Miller, Ralph Lindemann, Jerry Klenke, Tom Dix, Jo Clar, Linda Smith, Robert Jones Sr., Billy Bullock, Gerald "Jerry" Klenke, Schrader Funeral Home, Ballwin Elementary School, Central States Coca-Cola, and the City of Ballwin. The 2004 honorees include Stacy Zimmerman, Mike Piskulic, Howard "Skip" Tolles, Jerry Steudeman, Ron Reed, John Galus, Rick Shannon, Vickie Reynolds, Marilyn Barlow, Bob Spillenkothen, Sherry Stough, and the Parkway School District. In 2005, Bill Sloan, Phil Schroeder, Ernie Barlow, George Gould, and Jerry Halloran were recognized. (Photograph courtesy Jim Eschenbrenner.)

George Arft Jr., Hap Eschenbrenner, and Billy Bullock are pictured at the 2003 ceremonies. (Photograph courtesy Jim Eschenbrenner.)

The entrance to the Ballwin Athletic Association ballpark is shown as it looks today. It takes thousands of hours of volunteer labor to make possible the operation of the park. These parents are doing their part by selling slushies, nachos, candy, and other goodies to hungry players and spectators. They do a brisk business. For example, more than 6,400 hotdogs were sold through the concession stand in 2004. (Photograph courtesy Ballwin Athletic Association.)

In early 1978, Mayor Richard Andrews brought together a group of volunteers to plan an event for the entire community. They created Ballwin Days with the theme that first year, "A Fair to Remember." That event has become much larger than the original planners would have ever thought. The Ballwin Days Committee, with over 140 volunteers in 2004, manages the various facets of the event. The photograph showing the midway at night was taken by Carla Steckley during Ballwin Days 1990. The first Mr. and Mrs. Ballwin Days were Henry Koch and Martha Walka, seen below. They are joined by the first queen of Ballwin Days, Melodee Hinkle. Koch and Walka (ages 88 and 85, respectively) were Ballwin's oldest residents at the time.

Over the years, various events have been added to the festival. Some have lasted, like the five-kilometer race. It started as a one-mile and five-mile run in 1980. The photographs from 1999 above show runners on a tear through Vlasis Park toward the start of the race, and below, the top three finishers in the women's category, ages 20–29. From left to right they are Karen Tusinski, third place; Katie Tusinski, first place; and Carrie Holland, who finished second. Other popular activities are washers tournaments, the fishing derby, and the arts and crafts area for kids. For most of its existence, Ballwin Days took place in August on the weekend preceding Labor Day weekend. In 2002, redevelopment in Vlasis Park forced a move to the third weekend of June. Fairgoers loved the freedom from the back-to-school hubbub, and the change stuck.

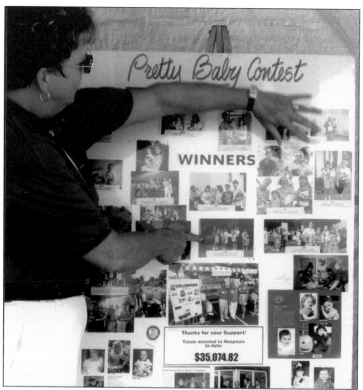

One very successful event has been the Pretty Baby contest, a fundraiser for Cardinal Glennon Children's Hospital. Between 1981 and 2004, more than 1,500 babies have participated, and more than $50,000 has been raised for the hospital. Here Pat Ferris highlights a display of past winners in 1998.

Various nonprofit organizations operate food and game booths at Ballwin Days. Participants in 2004 included groups such as Ballwin Metro-West Rotary with steak and chicken sandwiches and Scout Troop 357 with hot dogs, nachos, chili, and pepperbellies. The Ballwin Days committee served up funnel cakes and Ted Drewes frozen custard. Above, Jackie Holt prepares a funnel cake while police chief Jim Biederman looks on.

The annual designation of Mr. and Mrs. Ballwin Days is an opportunity for the community to honor those who have given of themselves to Ballwin over the years. Nominees must be at least 75 years old and must have lived in Ballwin for 25 years. They are selected on the basis of achievement or contribution within the Ballwin community or participation within a church or other charitable or nonprofit organization. In the top photograph, Channel 5 KSDK weatherman Scott Connell interviews Dot and Dick Andrews, Mr. and Mrs. Ballwin Days for 2001. In the bottom photograph are Wayman and Gladys Green, selected as honorees in 1998.

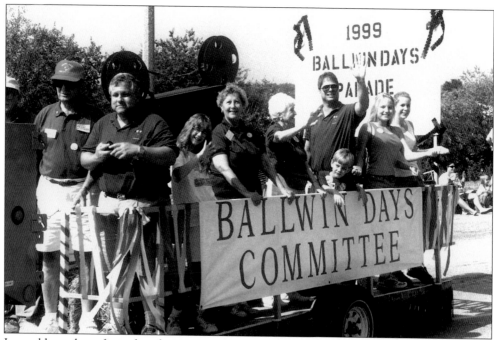

It would not be a festival without a parade. A portion of the 1999 Ballwin Days committee rides on the float above. With over 100 volunteers, you would need a much bigger wagon if you intended to fit them all on. From left to right are Roy Duenke, Gary Kramer, unidentified, Ginny Halloran, Dottie Andrews, Jim Lieber, and three unidentified. Below, Mayor Robert Jones rides with his wife, Jana, and sons Robby and Daniel in the 2000 parade. The chauffeur is police chief Jim Biederman. "The parade has between 100 and 150 units," says Pat McDermott, present co-chairman of Ballwin Days. The parade starts in Vlasis Park, travels west on Manchester Road, makes a loop on Steamboat and Kehrs Mill, and returns it to the park.

Six

A HERITAGE PRESERVED

The Ballwin Historical Commission, a formal citizens committee of the city of Ballwin, is officially charged with identifying historically significant components of the city and pursuing the best routes of preserving that heritage. This seal was created when the group was organized as the Ballwin Historical Society in 1991. It shows several of Ballwin's historically prominent structures. From left to right are Salem Methodist Church, John Ball's house, and the Barn at Lucerne. The open book represents the group's charge to preserve the area's history. The historical society became the Ballwin Historical Commission in 2001.

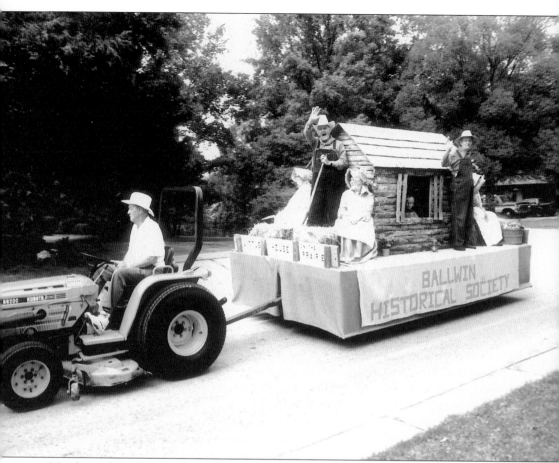

Members of the historical commission work to promote the heritage of the community in a number of ways. Sponsoring a float in the annual Ballwin Days parade has been an effective way to publicize its work in historical preservation. This photograph shows the historical society's float in 1993. Fern Whitmire remembers how the members would gather at their house to prepare the float. "We'd assemble it there," she says, "of course, with lots of snacks, cookies and lemonade and the like." Fern Whitmire's husband, John, did the driving from 1993 to 2002, first with a tractor and then with a truck. He sits at left. The people on the float are George Tribble (waving, center) with Fern Whitmire to his left and Fern Feldmann to his right. Wayman Green stands to the rear.

The Ballwin Historical Commission knew it would have to be proactive in identifying opportunities to preserve physical relics of the town's past. The group set its collective mind on finding a log cabin to fix up. "We tried three times to find a log home to restore," said Bill Buermann, past chairman. Then Verna Dahlke Arnold piped up one day in 1992. The home she had grown up in at 226 Holloway Road was going to be wiped out to make room for new construction. Arnold stands above at the right with her sister Bernice Dahlke Hoehne and Buermann. The 1996 photograph was taken by Ursula Ruhl of the Times Newspapers. Ownership was transferred to the city of Ballwin, and a suitable site within Vlasis Park was located for the structure, known as the Harrison-Schmidt-Dahlke Home. It is shown below as it looks today.

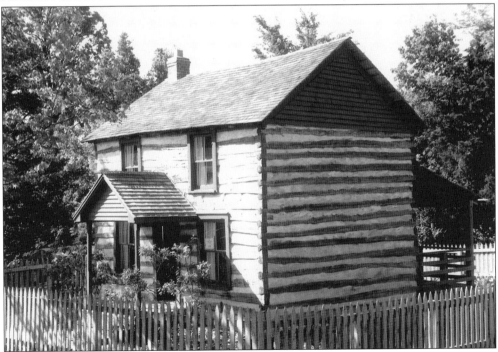

The city arranged for a firm specializing in log home restoration, Franklin and Francis, to disassemble the structure and re-create it in Vlasis Park. Beginning in the spring of 1993, dozens of volunteers worked on the project. After the project was laid, they helped raise the logs into place and fill the gaps with white chinking, made from mud, straw, seeds, and pebbles. "Since we didn't have to buy the building, all we were dealing with was the labor," said Bill Buermann, then president of the Ballwin Historical Commission. "There was a lot of volunteer help." The restored log home was dedicated in May 1993. The historical commission conducts tours of the log home for scout groups, schools, and other organizations.

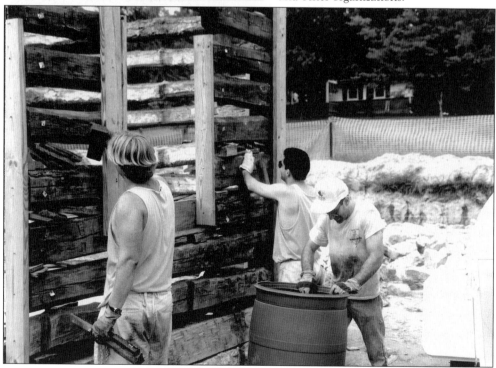

The structure is known as the Harrison-Schmidt-Dahlke Log Home because of its lineage of ownership. It was originally built in 1849 on the property of Joseph Harrison. Either he or his son and daughter-in-law, Joshua and Martha Ann (née Shotwell) Harrison were presumed to be the original occupants. Wilhelm and Henrietta Schmidt bought the home in 1870. In 1891, they sold it to Karl and Wilhelmina Dalhke. Both were born in Germany in 1860 and came to America in 1891 with four small children in tow. Two more children were born after they bought the home on Holloway Road, including Theodore (Ted) Dahlke in 1900. Dahlke, shown to the right, lived in the structure until he died in 1987. In addition to serving as volunteer fire chief, Dahlke was also a state champion skeet shooter. Because of its authentic restoration and period décor, the site serves as a historic backdrop for other events such as the May 1995 encampment by Civil War reenactors portraying the 8th Regiment, Missouri Volunteer Infantry U.S. The event featured displays of weaponry, drill, and ceremony plus women and children dressed in 1860s apparel and period games and dances.

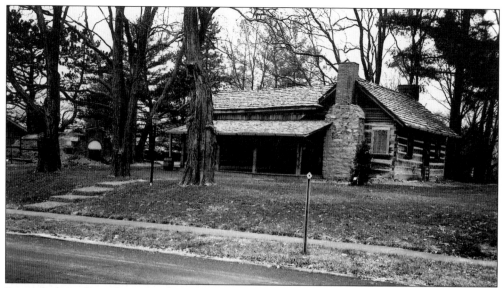

Expanding city boundaries has brought other historic structures within Ballwin city limits over the years. The Bacon Log Cabin, built in 1835, sits at Henry Avenue and Spring Meadows Drive and serves as the headquarters for the Old Trails Historical Society. They bought the property in 1969 and restored it. The structure carries the name of William Douglas Bacon, who lived in it during the late 1800s. (Photograph courtesy Old Trails Historical Society.)

Ballwin residents have always been particular about celebrating milestones in the city's history—from the 10-year blowout held in 1960 that featured baking contests and square dancing, to other milestones such as the 40th anniversary in 1990. A big one came in 2000—Ballwin's golden anniversary. Here, Mayor Robert Jones (holding cake) is joined by his wife, Jana (left), and Roy and Peggy Duenke in ceremonies held at the Pointe on December 29, 2000. The Duenkes chaired the committee that organized a yearlong celebration with multiple events.

As part of the 50th anniversary celebration in 2000, the city commissioned a commemorative quilt. Irene Wirsing, shown here, led the project and was responsible for the overall design of the quilt and for piecing together contributed squares. Irene herself also quilted squares representing the Bacon Log Cabin, Ganahl Dairy Company, the Barn at Lucerne, and the Harrison-Schmidt-Dahlke Log Home. Panels were contributed by 22 community groups. Wirsing created an additional three panels for the Ballwin Historical Society, the Old Trails Historical Society, and Ganahl Dairy Company. The quilt is made up of 28 squares total, including the ones shown here. From top to bottom and from left to right, they represent Trinity Lutheran Church, Holy Infant School, Ballwin Baptist Church, Ballwin Athletic Association, Selvidge Middle School, and the Barn at Lucerne. The quilt hangs today in the chambers where the board of aldermen meets.

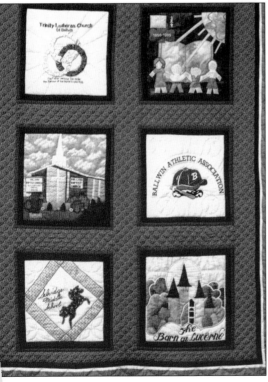

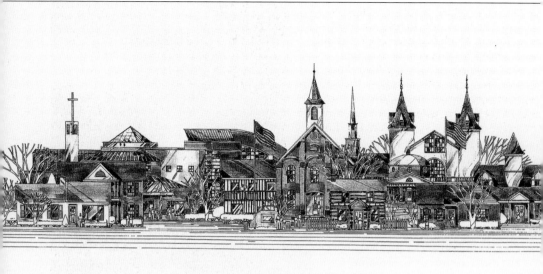

BALLWIN

M I S S O U R I

JOHN PILS

The city celebrated its 50th anniversary by commissioning a work by local artist John Pils. The piece shows prominent places from Ballwin blended in Pils's unique and distinctive style. Buildings represented include the Barn at Lucerne, Salem Methodist Church, the Coach House restaurant, and the Pointe at Ballwin Commons. The city sold copies of the poster for $20 or $30 depending on the size of the print, and proceeds helped fund fine arts activities in Ballwin. Pils, who is nationally known for his work, works primarily from his John Pils Posters studio at 104 Holloway Road in Ballwin, where he is surrounded by the drawings he has done over more than 20 years. His work is a virtual A to Z of St. Louis places, from the Arch, the brewery, and Busch Stadium to Union Station, Washington University, and hundreds more.

Progress meant some fancy footwork was necessary again in 1990 to relocate Ballwin's roll of honor, which had been made virtually inaccessible because of the continuing encroachment by Manchester Road. The memorial was originally raised in October 1944 to honor those from Ballwin who served in World War II. Situated in the churchyard of Salem Methodist Church, the steps shown in this photograph were lost when Manchester was broadened to four lanes in the 1960s. Rev. Larry A. Williams, Salem's pastor, told the Press Journal in December 1990, "We want it placed in a location to appropriately honor the local people named on the monument."

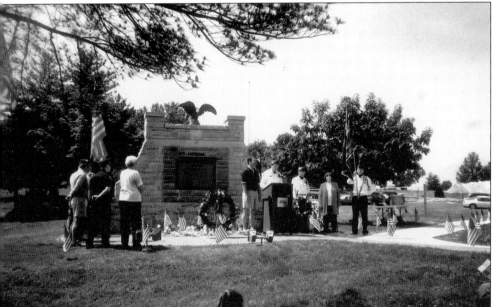

Representatives of area veterans groups routinely place wreaths at the World Peace Memorial at its new site in Vlasis Park each year on Memorial Day and Veterans Day. This photograph was taken at ceremonies marking Memorial Day 2002. Mayor Robert Jones and other dignitaries attended. The color guard from VFW Post 6274 served in the ceremonies, and a bugler played taps. (Photograph courtesy Dot Andrews.)

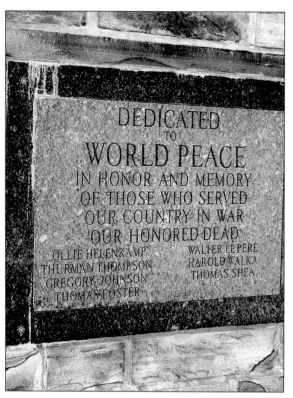

At first, a box with a glass cover sat where the red granite stone is now. When the monument was first established in October 1944, the war was not finished, and this allowed additional names to be added as fighting continued. Ballwin VFW Post 6274 later provided the granite insert that today bears the names of two men killed in action during World War II, Thurman Thompson and Harold Walka. It also lists one from World War I, Walter LePere, for whom the American Legion Post 208 is named, as well as three servicemen killed in Vietnam—Gregory Johnson, Thomas Shea, and Thomas Foster. Starting July 29, 1991, the monument was disassembled piece-by-piece and trucked to Vlasis Park, where Bob Potocnjak, a retired stonemason, reassembled it with help from Andy Noles next to the police station. It was rededicated as the Peace Memorial on November 10, 1991, as part of Veterans Day observances.

THE WHITE HOUSE
WASHINGTON

November 5, 1991

I am delighted to send my warmest greetings to everyone participating in the rededication of Ballwin's World Peace Monument.

Throughout our nation's history, the American character has been marked by goodness and generosity. The American people have long been known for their readiness to contribute their time and talents toward improving communities and assisting those in need.

Your gathering is testimony that the spirit of neighbor-helping-neighbor is alive and well in our land. I commend all of you for your dedication to building a better America.

Barbara joins me in sending you our best wishes for a memorable event. May God bless you all.

G. Bush

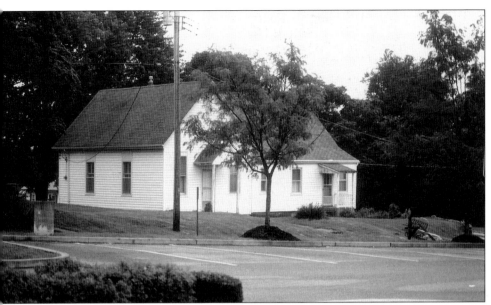

hen the redevelopment of old town Ballwin was approved, one of the conditions for the
:veloper was that the Old Ballwin School be relocated and preserved. After the construction
the new school at 400 Jefferson Avenue in 1938, the old schoolhouse was transformed into a
ivate residence, with the two main rooms each divided again into smaller spaces. It is shown
)ove as it appeared in 1999. In addition to the cost of the actual move from its location at 110
m Street, the developer, Regency Centers, contributed $65,000 toward its restoration and
1 acre of land east of the current Ballwin Elementary School as a permanent location for the
ructure. In the second photograph, once the demolition of the structures in Ballwin's original
•wn center began in preparation for construction on the site, the old school was jacked off its
undation, loaded onto a trailer, and hauled to its new home.

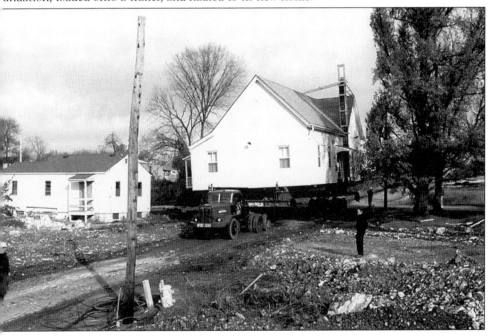

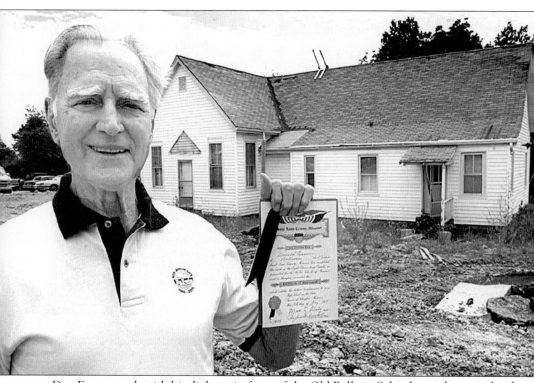

Don Essen stands with his diploma in front of the Old Ballwin School in a photograph taken 2001 by *Press Journal* photographer Rick Graefe. Essen attended the school from 1927 to 193[?] Mille Wallace captures the school in the poem "My Schoolhouse."

My town was just a small town,
The schoolhouse very small
Two rooms that were on one floor,
Divided by a hall.

But I loved that little schoolhouse
As I learned my A, B, C's
The cloakroom small the windows tall
And outside the big trees.

Oh yes, there was a cellar door
To slide down when at play
A baseball field which was so small
But we liked it just that way.

Seesaws and swingset
Were part of the array
And even a long sidewalk
So hopscotch we could play.

We started out the school day
With songs we sang with glee
Like "America the Beautiful,"
"My Country 'tis of Thee."

I know the little schoolhouse
From which I got my start
Will always be a part of me
Hidden deep within my heart.

Since relocation, the schoolhouse has received a new bell tower and new siding. Allen Roofing made a substantial in-kind donation of materials and labor to put a new roof on the structure. One of the rooms is in the process of being restored to the way it looked as a classroom. The Ballwin Historical Commission has been collecting desks and other fixtures to that end. Society members and city staff visited the school in 2002 after the move to inspect the work in progress. From left to right are Linda Bruer, John Hoffman, Mel Walka, Lauren Strutman, Ruth Arft, Ralph Streiff, and Don Essen. Bruer and Hoffman are parks and recreation employees, and Strutman is a Chesterfield-based architect specializing in historical restoration who put together the drawings and plans to restore the interior of the structure.

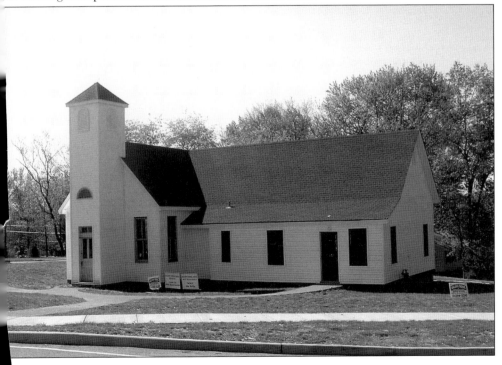

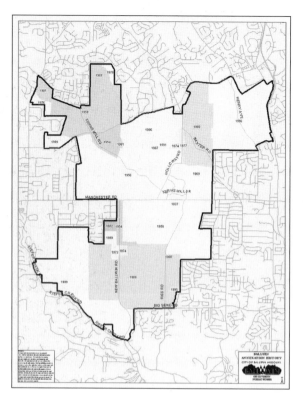

Ballwin has added to its borders over time, increasing a great deal from the original two and a half square miles defined under the original incorporation. This map shows how various pieces have been added to the city since 1950. The biggest period of growth came in the 1990s, when the series of annexations nearly doubled the size of the city. The commission is again accepting proposals for annexation, particularly in the unincorporated areas to the south.

The 2000 population of Ballwin was 31,283. The average elevation is 650 feet above sea level. The highest point in St. Louis County (800 feet above sea level) is in Ballwin, at the intersection of Clayton and Kehrs Mill Road; on a clear day, you can see the Gateway Arch from there. Ballwin covers 10 square miles and has 122 miles of city streets. Ballwin has 9,837 single-family homes, 718 condos, and 1,710 apartments. There are 481 businesses operating within the town.